Painting Nature
in PEN & INK
with WATERCOLOR

Claudia Nice

NORTH LIGHT BOOKS
CINCINNATI, OHIO

ABOUT THE AUTHOR

Claudia Nice is a native of the Pacific Northwest and a self-taught artist, developing her realistic art style by sketching from nature. She is a multi-media artist, but prefers pen, ink and watercolor when working in the field. As an art consultant for Koh-I-Noor Rapidograph since 1983—and more recently for Grumbacher—Claudia has traveled across North America conducting seminars, workshops and demonstrations at schools, clubs, shops and trade shows. Her oils, watercolors and ink drawings have won numerous awards and can be found in private collections across the continent.

Claudia has authored twelve successful art instruction books, including *Sketching Your Favorite Subjects in Pen and Ink* and *Creating Texture in Pen and Ink With Watercolor*, both of which were featured as main selections in the North Light Book Club.

When not involved with her art career, Claudia enjoys hiking and horseback riding in the wilderness behind her home on Mt. Hood in Oregon. Using her artistic eye to spot details, Claudia has developed skills as a man-tracker and is involved, along with her husband Jim, as a wilderness Search and Rescue Volunteer.

Painting Nature in Pen and Ink With Watercolor. Copyright © 1998 by Claudia Nice. Manufactured in China. All rights reserved. No part of this book may be reproduced in any form or by any electronic or mechanical means including information storage and retrieval systems without permission in writing from the publisher, except by a reviewer, who may quote brief passages in a review. Published by North Light Books, an imprint of F&W Publications, Inc., 1507 Dana Avenue, Cincinnati, Ohio 45207. (800) 289-0963. First edition.

02 01 00 99 98 5 4 3 2 1

Library of Congress Cataloging-in-Publication Data

Nice, Claudia
 Painting nature in pen and ink with watercolor / by Claudia Nice
 p. cm.
 Includes index.
 ISBN 0-89134-813-1 (hardcover)
 1. Pen drawing—Technique. 2. Watercolor Painting—Technique. 3. Nature
(Asthetics) I. Title.
NC905.N528 1998
741.2'6—dc21 98-12672
 CIP

Edited by Jennifer Long
Production edited by Patrick Souhan and Michelle Howry
Designed by Brian Roeth

I dedicate this book to my naturalist friend Winnie, who taught me wilderness wisdom, and to my adventurous friends Becky, Jan, Nellie and Jeanne, who taught me the meaning of kindred spirits.

My deepest thanks and respect to the Father of all creation, who blessed the earth with so much beauty and diversity.

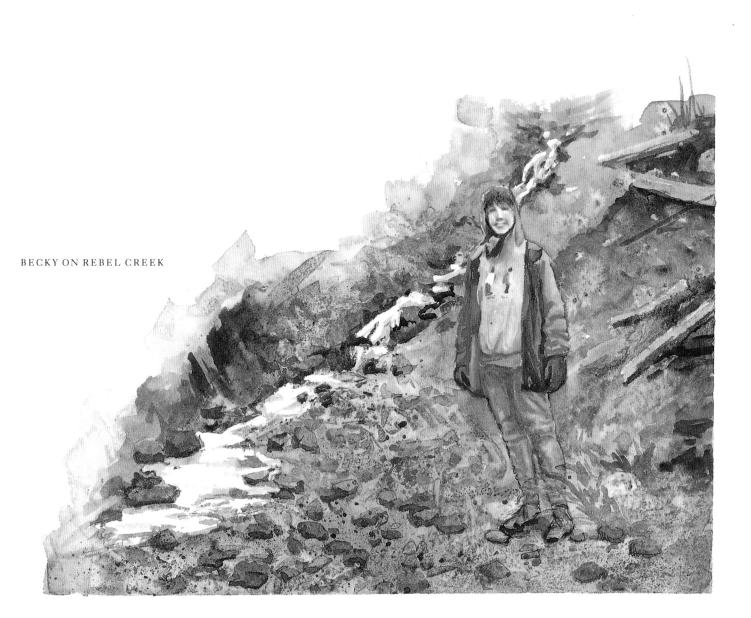

BECKY ON REBEL CREEK

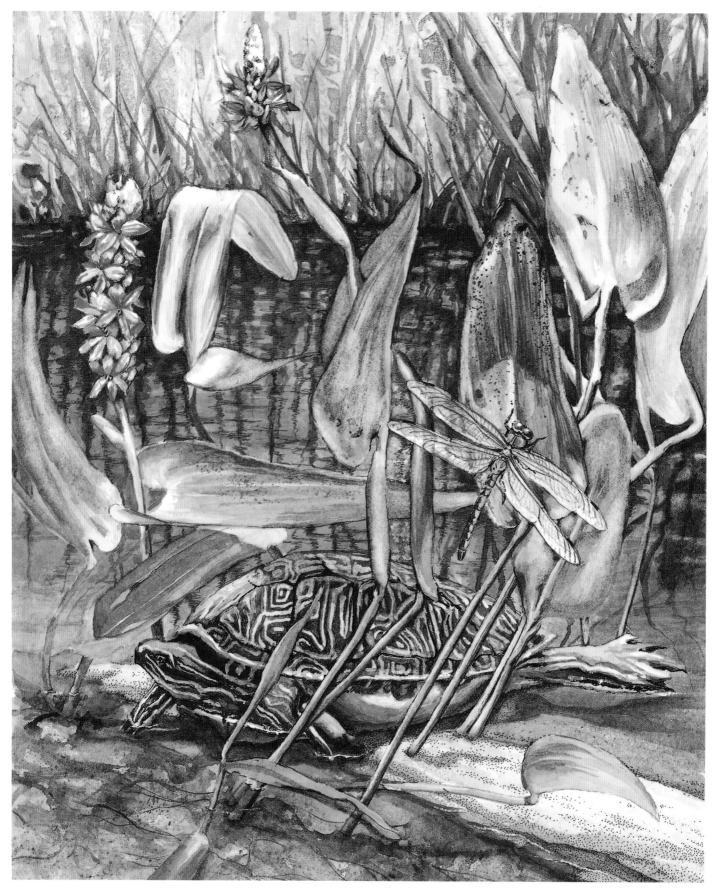

AT THE EDGE OF THE MARSH, 8″×10″ (20cm×25cm), Watercolor textured
with ink stippling, spatter, plastic wrap and thread impressions.

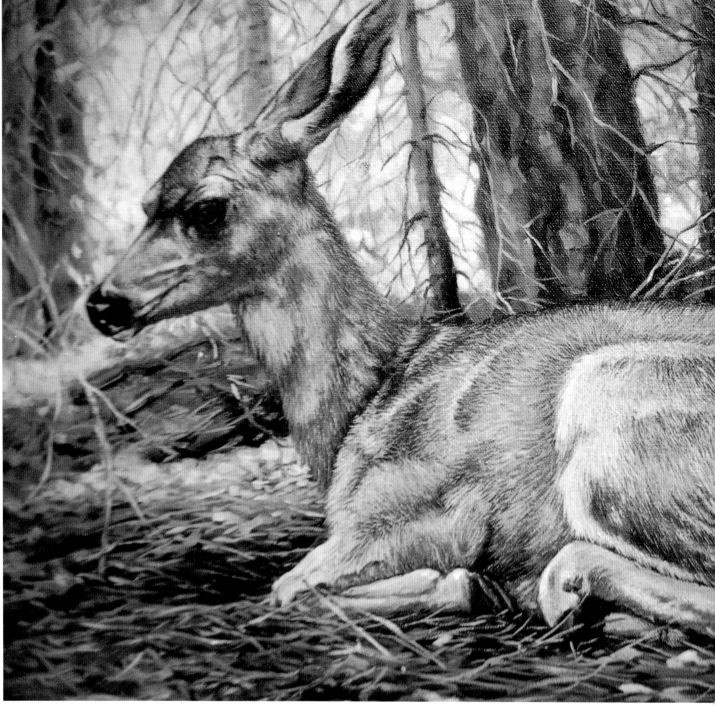

THE YEARLING—PSALMS 37, 16″×20″ (40.6cm×50.8cm), oils

INTRODUCTION

To become one with nature is to enjoy life to the fullest. For me it's not enough to stroll by and view it from afar, like a spectator at a game. I need to move in close—to touch, to sniff, to ponder and become part of my surroundings, if only briefly. Only then can I begin to *see* what I'm looking at—to perceive the shapes, textures, colors and contrasts that excite my "artist's eye." Familiar sights, sounds and smells recall nostalgic memories, while the unfamiliar invites the child within to come out and explore. The result—damp shoes, dirty knees, windblown hair and a greater love and appreciation for the puzzle pieces of this world and the touch of the Master's hand who orchestrated it all.

I will always remember when I visited Mt. Lassen, California, in the early spring. I followed a doe and her yearling fawn part way around a lake, trying to get close enough to take a good photograph. After a while, I tired of the chase and settled down in a shady pine thicket to rest. There I sat, in a deep bed of pine needles, my back against a tree and my mind tuned into the forest sights and sounds. I was totally at peace. Silently, from the edge of the thicket, the two deer appeared. With little hesitation, they bedded down, the yearling literally at my feet. Her eyes held no fear, only curiosity. The light filtering down through the tree limbs edged the deer's coat in gold. Did I get my photo? You bet! It has been the basis for many sketches and paintings, including the one on the opposite page.

It's my hope that this book will encourage you to seek out and see the wonders of nature close up, with an artist's eye, and that the hints, notes and examples on these pages will help you capture your discoveries with pen and brush so they may be shared and remembered for many years to come.

Best wishes,

Claudia Nice

GETTING STARTED

MATERIALS

Good tools and art supplies are essential to the success of a project. The learning process and the joy of creation can be greatly discouraged when the artist has to fight with his or her art equipment in order to succeed. You need not buy the most expensive tool, but you must learn the nature of each implement to choose wisely in an affordable price range.

Watercolor paper

Choose a paper that is compatible to penwork, as well as wet washes. The paper should be polished enough to allow the pen to glide over its surface without snagging, picking up lint or clogging. The ink should appear crisp. On the other hand, the watercolor paper must be absorbent enough to avoid permanent buckling when wet-on-wet techniques are used. Taping the edges of the paper to a board while painting will help the paper maintain its original shape. I use a cold-pressed, 50 percent rag, medium weight (125 lb. or heavier), pH neutral paper.

The pen

The ideal pen has a steady, leak-free flow and a precise nib that can be stroked in all directions. This book was illustrated using Koh-I-Noor Rapidograph pens. They consist of a hollow nib, a self-contained, changeable ink supply and a plastic holder. Within the hollow nib is a delicate wire and weight which shifts back and forth during use, bringing the ink forward. The Rapidograph comes in a variety of sizes, 0.25 being the one used most often in my work. (Throughout this book, the nib size I used for each sketch is noted in parenthesis near the artwork.) Two drawbacks of the Rapidograph pen are cost and maintenance. Like any instrument, the Rapidograph requires proper care and cleaning.

A more economical and maintenance-free version of the technical pen is the disposable Artist Pen by Grumbacher. It comes prefilled with a quality, brushproof ink. The Artist Pen is similar in usage to the Rapidograph, but differs somewhat in design, the inner workings being "sealed." Drawbacks for the Artist Pen are that you don't have a choice of inks, and empty pens are not refillable.

Dip pens are very economical, consisting of a plastic or wooden holder and changeable steel nibs. With Hunt nibs no. 102 (medium) and no. 104 (fine), the Crow Quill dip pen will provide a good ink line. It cleans up easily and is useful when many ink changes are required. The drawbacks are that Crow Quill pens are limited in stroke direction, they must be redipped often and they tend to drip and spatter.

Ink

For mixed media work, choose an ink that is lightfast, compatible with the pen you are using and "brushproof"—which means that it can withstand the vigorous overlay application of wet washes without bleeding or streaking. Permanent inks are not necessarily brushproof and must be tested. For a very black, brushproof India ink, I recommend Koh-I-Noor's Universal Black India 3080.

For softer, more subtle ink lines, choose compatible, brushproof colored inks. Transparent, pigmented, acrylic-based inks are preferable, as dye-based inks often fade quickly. I used Koh-I-Noor Drawing Ink 9065 for the colored inkwork in this book. However, the white and black 9065 are not recommended for technical pens.

Paint

Look for a watercolor paint that has rich, intense color, even when thinned to pastel tints. It should be finely ground and well-processed, so washes appear clean, with no particle residue. Colors should have high lightfast ratings. While there are many quality brands to choose from, the paintings in this book were done with Grumbacher Academy and Finest watercolors. Whichever brand you choose, remember that it's better to have a limited palette of quality paints than a kaleidoscope of inferior substitutes.

Brushes

The best watercolor brushes are made of sable hair. Soft, absorbent sable brushes are capable of holding large amounts of fluid color, while maintaining a sharp point or edge. They respond to the hand with a resilient snap. However, they are expensive. A good sable hair blend or quality synthetic brush can provide an adequate substitute. Avoid brushes that go limp and shapeless when wet, or are so stiff they won't flow with the stroke of your hand. Here's an upkeep hint—use your watercolor brushes only for watercolor.

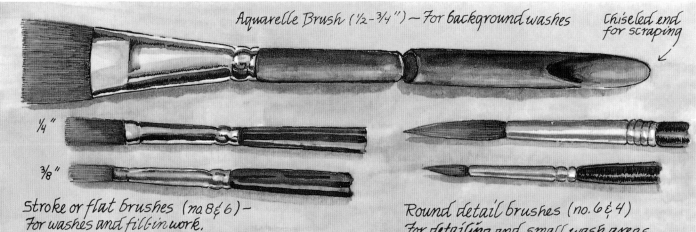

Aquarelle Brush (½-¾") — For background washes

Chiseled end for scraping

¼"

⅜"

Stroke or flat brushes (no. 8 & 6) — For washes and fill-in work.

Round detail brushes (no. 6 & 4) For detailing and small wash areas.

Other useful tools

- Pencils and eraser for sketching
- Liquid frisket (masking fluid) to protect white paper areas
- Old round brush or The Incredible Nib (felt tip) for applying frisket
- Masking tape for taping paper edges and removing liquid frisket
- Stylus or toothpicks for bruising
- Rock and table salt, alcohol, plastic wrap, spray mister, etc. for texture
- Tweezers for placing rock salt, leaves, etc.
- Razor blade for scratching through dry paint
- Several small sea and synthetic sponges for daubing
- Facial tissue and paper towels for blotting

For additional information on tools and techniques, refer to my other books *Sketching Your Favorite Subjects in Pen and Ink*, *Creating Textures in Pen & Ink With Watercolor* and *Drawing In Pen and Ink*, all published by North Light Books.

Basic Pen Stroking Techniques

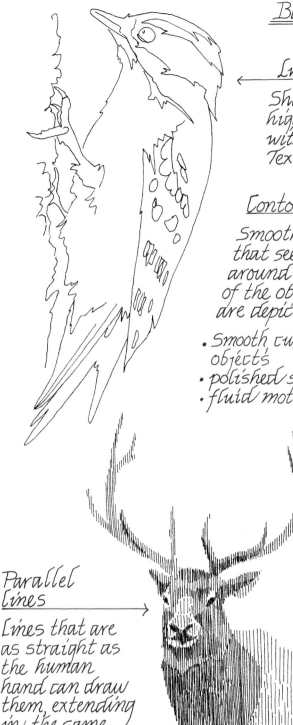

Line drawing

Shape, shadows and highlights are suggested with a simple outline. Texture is not shown.

Contour lines

Smoothly drawn lines that seem to wrap around the surface of the object they are depicting.

- Smooth curved objects
- polished surfaces
- fluid motion

Note ~

Moving lines closer together or layering produces darker values.

Parallel lines

Lines that are as straight as the human hand can draw them, extending in the same direction, at the same angle.

- smooth, flat objects
- objects obscured by rain, fog, darkness etc.
- Distant objects.

Crosshatching

Two or more sets of contour or parallel lines that are stroked in different directions and intersect.

- deepen tonal values (shadows)
- create roughened texture varying in degrees according to angle, precision and nib size.

Stippling

A series of dots produced by touching the pen nib to the paper, while the pen is held in a vertical position.

- subtle value blends
- multi particle look
- antique, dusty quality
- soft, velvety appearance

Scribble lines

Continuous, looping, free form lines

- quick sketches
- thick, tangled look
- foliage & moss

Crisscross lines

These are randomly crossing, hair-like strokes.

- fur, hair
- grass, rushes
- bird body feathers

Wavy lines

Lines that are drawn side by side, forming a grain-like, rippling pattern.

- wood and marble grain patterns
- rippled water rings
- feather barbs
- veined grasses
- flaxen hair

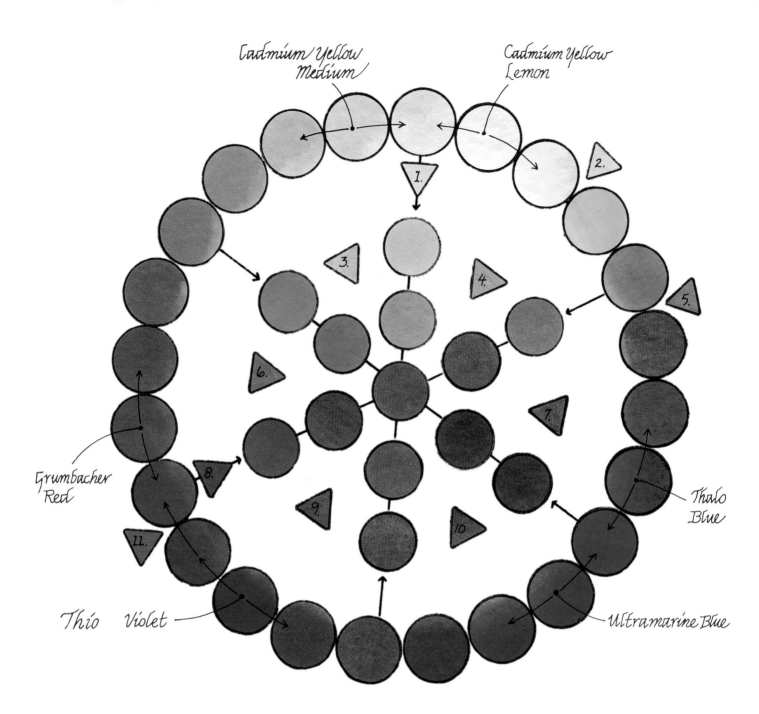

The color chart above shows a simple palette of six basic colors, consisting of a warm and cool red, yellow and blue. These intense mixing colors will produce vibrant, accurate secondary colors (oranges, greens and violets). Red, yellow and blue can be obtained by combining the related warm and cool base colors together. Shading colors, browns and neutrals can be mixed by combining complementary colors (colors opposite each other on the color wheel).

The triangular-shaped hues represent a few of my favorite premixed tube colors. Having them on hand is convenient, but optional.

1. Gamboge
2. Thalo Yellow Green
3. Yellow Ochre
4. Sap Green
5. Thalo Green
6. Burnt Sienna
7. Sepia
8. Brown Madder
9. Burnt Umber
10. Payne's Gray
11. Thalo Red (hard to duplicate by mixing)

Basic Watercolor Techniques

Dry Surface:
Paint applied to a dry surface is readily absorbed, producing distinct hard edges. This is a good technique for fine detail work.

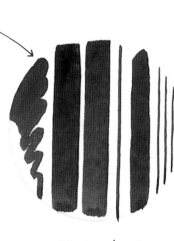

Drybrushing:
A paint-filled, blotted brush, applied to a dry surface results in crisp, precise lines. As the brush dries out, paper texture marks appear.

Flat Wash:
Fluid paint, brushed evenly over a dry or slightly damp surface produces smooth, uniform washes.

Varied Wash:
As the flat wash is applied, the brush is dipped alternately in several different color mixtures.

Graded Wash:
Washes blend easily when brushed over a damp surface. As you work, stroke in more or less pigment to increase or decrease the value of the wash.

Softened Edges:
A moist or layered edge may be softly blended by stroking it with a clean, damp brush. Clean the brush every fourth stroke.

Layering / Glazing:
Values may be deepened or colors changed by stroking one wash over another. Let each wash completely dry before adding the next.

Wet-On-Wet
Paint applied to a shiny wet (not runny) surface will flow freely, creating spontaneous, feathery designs.

13

Special Effects

Masking:

Liquid frisket applied to a dry surface will preserve what's beneath while washes are brushed over the top.

(Remove by dabbing with masking tape.)

Bruising:

Gently stroke a stylus through a wet wash, bruising the paper surface. Pigment will gather in the slight indentations.

Scraping:

Create highlights by scraping a blunt tool through a near-dry wash, or a razor blade through dry paint.

Spatter:

Fluid paint flicked or flung over a dry surface creates spontaneous spots. A damp surface softens the effect.

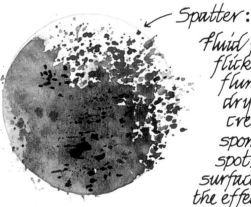

Water Spots:

Drops of water, dribbled or flicked into a wet wash will create flow designs and puddling.

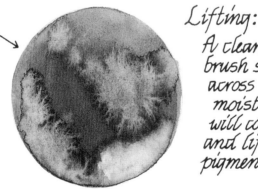

Lifting:

A clean, damp brush stroked across a moist wash will collect and lift pigment.

Blotting:

Pressing an absorbant material (paper towel) into a moist wash creates various light value patterns.

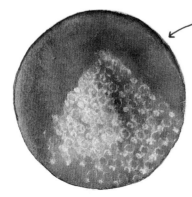

Blotting:

Gently pressing a crumpled facial tissue into a moist wash creates a wrinkled, textural effect.

Note: In a humid climate, pre-dry the table salt in an oven or microwave.

Table Salt:

Sparingly sprinkle table salt over a very moist wash and leave it undisturbed until the wash dries.

Rock Salt:

Using tweezers, dip the rock salt crystal in water and lay it into a moist wash. Do not remove it until wash is dry.

Alcohol Texturing:

Dip a round brush in isopropyl alcohol, blot and stroke through a damp wash. Pigment will push aside.

Alcohol Drops:

Drip or flick alcohol into a damp wash and light value rings and spots will appear.

Plastic Wrap:

Crumple plastic wrap and press it into a wet wash. Secure it until dry. Pigment will gather into a dark, crinkled design.

Impressed Textures:

Pat limp leaves, sand, hair, etc. into a wet wash and leave until dry. Gathered pigment will create a dark image.

Leaf Prints:

Paint a leaf with a thick, moist coat of watercolor and press it to a dry surface, leaving a print. (Pressed, dried leaves work best.)

Sponging:

Coat a damp sponge with paint and press onto a dry surface. Layered sponge prints make good background foliage.

Keeping A Sketchbook Journal

I use my bound sketchbook as an artistic journal, recording memories, sketching scenes, capturing details of nature and documenting interesting shapes, textures and backgrounds that may prove useful later on.

To help my memory, I record the title of the subject, place, date and various field notes describing colors, sizes and other non-apparent details.

Pencil, pen & ink and light watercolor washes work well on most journal papers.

Toad Living In Our Garden
Oahu, Hawaii – 1972
(drawn life size)

Leaves very dry and brittle

Alder Leaf Study
Oxbow Park, OR.
Late August – 1978

pale grayish-white with brown gills

Never apologize for journal sketches, no matter how rough they are depicted. Drawings need only catch the essence of the subject to spark a memory.

Mushrooms
Oyster Bay,
WN. 1980

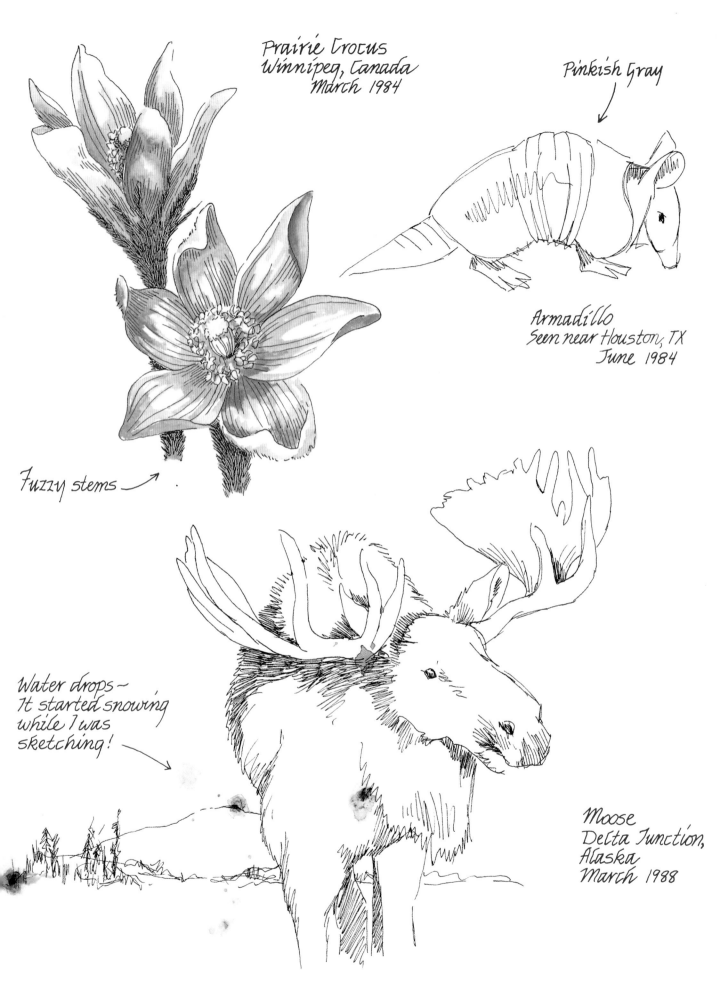

Prairie Crocus
Winnipeg, Canada
March 1984

Pinkish Gray

Armadillo
Seen near Houston, TX
June 1984

Fuzzy stems

Water drops ~
It started snowing
while I was
sketching!

Moose
Delta Junction,
Alaska
March 1988

17

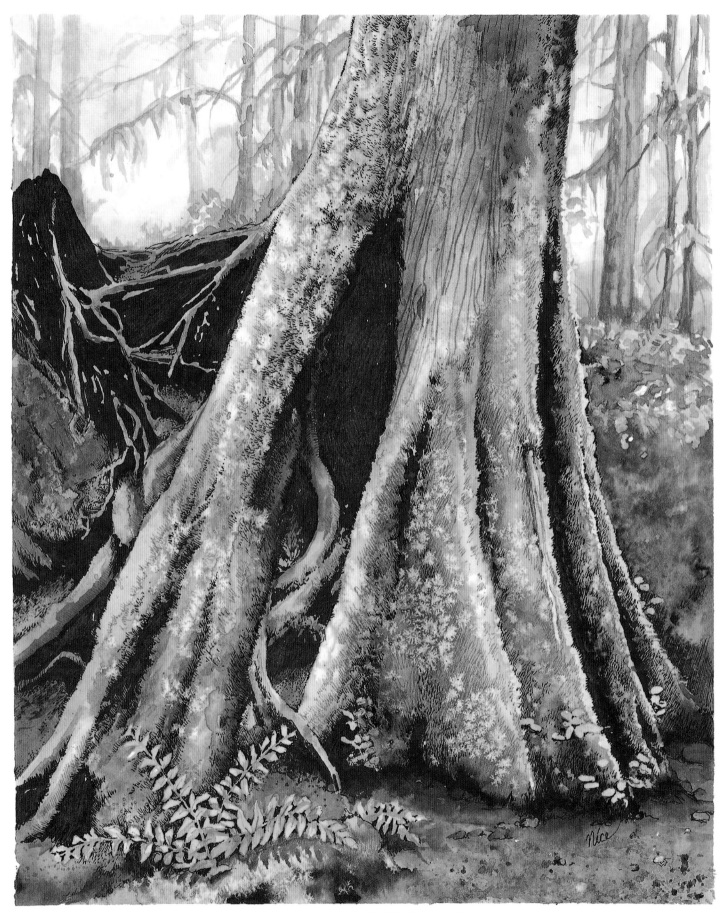

BENEATH THE TREES, 8″ × 9½″ (20.3cm × 24.1cm),
watercolor washes textured with salt and penwork

THE FOREST FLOOR

Pause for a moment in the deep forest. Conifer and hardwood branches sway overhead, casting dappled leaf patterns across the forest floor. Here, lush mosses, ferns and vine-like ground cover spring from the rich humus or the bark of fallen giants. Look carefully among the greenery and see the shy woodland wildflowers. Violets, lilies and dwarf orchids peek out from their hiding places in quiet splendor. Bold mushrooms pop up and stand guard like toy soldiers in oversized helmets.

On the forest floor, a cathedral quiet prevails, broken only by a chorus of thicket birds, the preaching of a zealous squirrel and the amen echoes of the tree frogs. It invites the wanderer to linger, and the artist to fill a sketchbook with a variety of shapes, hues and textures laid out in earthly elegance. But where to begin?

In this chapter I have "zeroed in" on a few of my favorite forest floor subjects and suggested some easy ways to portray them. Complicated flora and fauna can be broken down into basic shapes, or in the case of some plants, simply "printed" into place. Once they're sketched, just add color and texture to bring them to life. I'll guide you in the mixture of some lifelike earth hues and the creation of realistic texture, using a variety of fun techniques.

When the individual forest characters have become familiar old friends, I'll show you how to combine them into a composition. You are welcome to duplicate my paintings or alter them to fit your own visions. Better yet, stroll into the forest where the sights, sounds and smells are vivid, and see where the inspiration will lead your own creativity.

Thicket Birds

Flitting through the understory of the forest are the small mousey-brown song birds, like the Wren, Chickadee, flycatcher and Sparrow. Their earth-tone camouflage makes an excellent contrast to the bright green forest foliage in a composition.

House Wren quick study

Payne's Gray

Fox Sparrow

①

Preliminary pencil study

Burnt Sienna and Ultra-marine Blue

Burnt Sienna, Thio Violet and a touch of Ultramarine Blue to mute the mixture

②

Base damp surface washes applied with a small stroke brush

③

More watercolor washes layered on and blended at the edges. Details and texture were added last.

no. 2 round brush

Crisscross pen strokes (.25) Brown ink

Chickadee

Variegated
wet-on-wet washes.

Table salt sprinkled
into a moist wash.

Brown
crisscross pen work.

India Ink scribble
lines, tinted with washes.
(.18)

Moss

Mosses are tiny plants which
lack roots and true stems. Seldom
drawn in fine detail, the soft,
tangled texture and rich,
luminous green color are the
most important factor to the
artist.

Water from mist bottle sprayed
on wet wash.

Bruised
wood grain

Gamboge

Thalo
Yellow
Green

Sap
Green

Burnt
Sienna &
Umber

Sap Green

Payne's Gray

Light
moss areas
were masked.

Scribbled
pen work

21

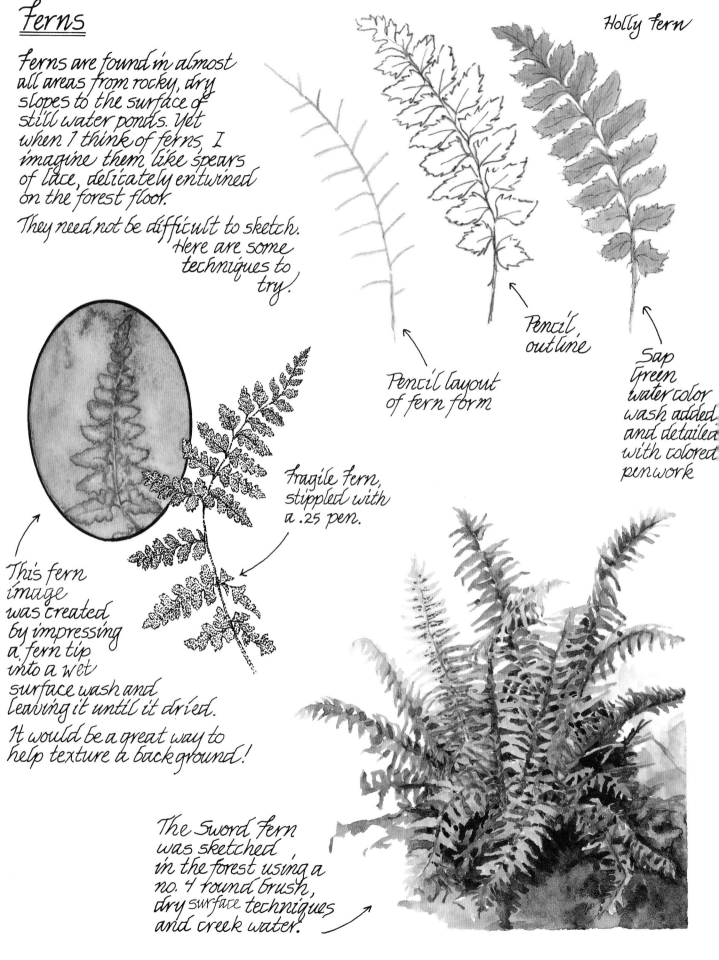

Ferns

Ferns are found in almost all areas from rocky, dry slopes to the surface of still water ponds. Yet when I think of ferns, I imagine them like spears of lace, delicately entwined on the forest floor.

They need not be difficult to sketch. Here are some techniques to try!

Holly fern

Pencil layout of fern form

Pencil outline

Sap Green water color wash added and detailed with colored penwork

Fragile fern, stippled with a .25 pen.

This fern image was created by impressing a fern tip into a wet surface wash and leaving it until it dried.

It would be a great way to help texture a background!

The Sword fern was sketched in the forest using a no. 4 round brush, dry surface techniques and creek water.

Young, tender ferns can be used for stenciling and stamping techniques. (Stiff, contoured ones need to be pressed and dried.)

Stenciled Oak fern

Stippled pen work

When background paint is dry, the fern image may be tinted and detailed with a brush or pen work.

Stenciling

Place fern to be used as a stencil against the paper. Using a soft stroke brush, apply the dark background color. Stroke over the fern leaflets and away from the center veins. Remove fern and let paint dry.

Stamping

Coat the surface of a fern with a heavy water-color wash. (If paint won't stick, stroke it first with a permanent marker.) Press the painted fern to the paper, cover with two sheets of paper towel and rub with your finger to transfer the moist paint from the fern to the paper surface. Remove fern and let print dry.

Lady Fern print

(Fern color mixture - Sap Green, Thalo Yellow Green and a hint of Burnt Umber)

Right side of print was enhanced with brush work and brown ink detailing

23

"Fox Sparrow And Ferns" was painted in the rich greens and earthy browns that bring to mind the lush colors of a moss laden rain forest.

(See the preceding pages for ideas on painting and inking the moss, ferns and bird.)

The aged brown fern and the edges of the bird and mossy stump were masked, then the entire background area was painted with a medium, wet-on-wet wash of Thalo Yellow Green, Sap Green and Burnt Umber in varied mixtures.

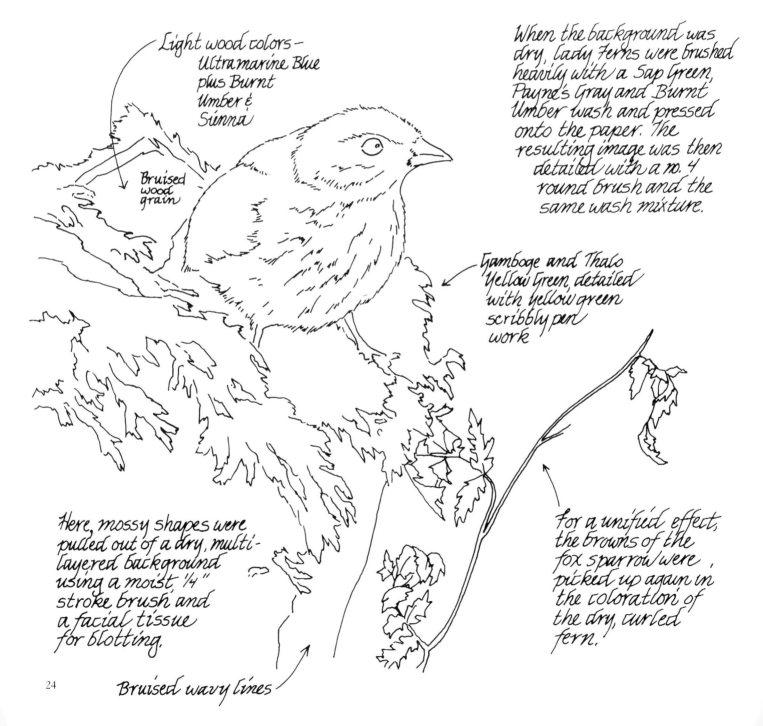

Light wood colors — Ultramarine Blue plus Burnt Umber & Sienna

Bruised wood grain

When the background was dry, Lady Ferns were brushed heavily with a Sap Green, Payne's Gray and Burnt Umber wash and pressed onto the paper. The resulting image was then detailed with a no. 4 round brush and the same wash mixture.

Gamboge and Thalo Yellow Green, detailed with yellow green scribbly pen work

Here, mossy shapes were pulled out of a dry, multi-layered background using a moist, 1/4" stroke brush and a facial tissue for blotting.

For a unified effect, the browns of the fox sparrow were picked up again in the coloration of the dry, curled fern.

Bruised wavy lines

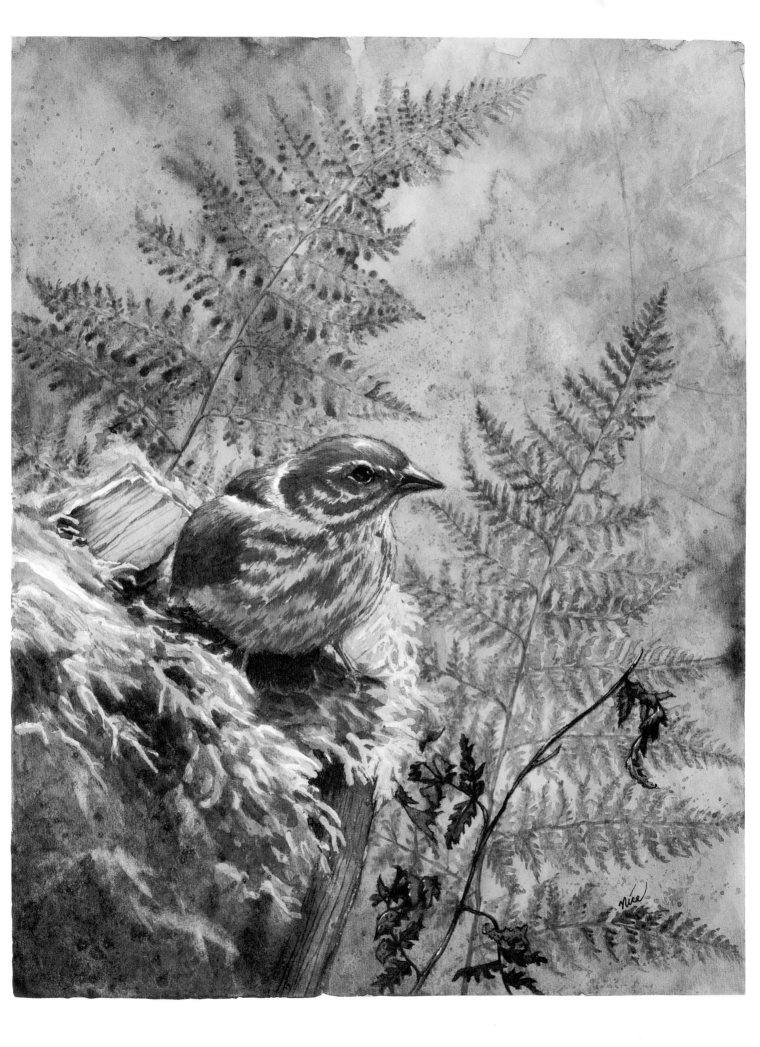

Mushrooms

Mushrooms, with their unusual shapes and varied colors, make wonderful subjects to complement a forest scene or quick sketch into a journal. The mushrooms drawn on this page can be found growing throughout most of North America.

Velvet Foot

(.25) Brown ink

Violet mixture, plus Burnt Umber

Yellow Ochre mixed with Burnt Umber

Yellow Ochre plus Burnt Sienna

Yellow Ochre with Thalo Red added

Fly Agaric (poisonous)

Blewit
Grows in compost at the edge of the woods.

The edge of this Morel was masked, and a crumpled plastic wrap was impressed into a wet wash and left until dry.

Layered washes

(.25) India ink

Gypsy Mushrooms

Soil defined with scribbled pen work.
(.25)

Morel Mushrooms

These small spring mushrooms have a honey-comb look that's fun to sketch. They are edible and choice.

Soil Textures

Just as soil make-up and color may vary from place to place, ways to depict the soil are also quite numerous. I usually begin with a flat or varied (damp surface) wash, then add a little texture.

Burnt Umber & Ultramarine Blue

Stamped with a man-made sponge

Burnt Sienna with streaks of Burnt Umber & Payne's Gray

Spattered with water drops

Burnt Umber & Payne's Gray

Stippled with a bristle brush and spattered

Damp Top Soil

Sandy Soil
(Detailed with stippling - .25)

Red Clay Loam
(Finished with a spattering of varied, dark washes)

Burnt Umber and Payne's Gray, impressed with plastic wrap

Stippled pen work

Humus With Bark Chips

Grass and pine needles were masked

Impressed leaf print

Conifer Forest Duff

Forest Amphibians

These shy creatures are moisture seekers. Treefrogs use enlarged sticky toes to climb amongst damp foliage, while newts and salamanders burrow under fallen leaves and rotten wood. These terrestrial amphibians return to water to breed.

The Spring Peeper (left) and the Gray Treefrog (below) are both nocturnal treefrogs found in eastern America!

(.18) India ink

(.25) Brown ink

Preliminary pencil sketch

Pacific Treefrog (West coast)

flat washes

Additional wash layers provide shading, while pen stippling creates texture.

Most treefrogs can change color and tend to assume the hues of their chosen habitat.

Lemon Yellow plus Sap Green

Thalo Green added to above mixture

Burnt Sienna plus Burnt Umber

Burnt Umber and Violet

Brown contour pen lines

Maple Leaf

Painted with a flat wash of Yellow Ochre and layered with mixtures of Burnt Sienna, Burnt Umber and Violet.

Spotted Salamander (Eastern)

(.18) India ink

The Rough-skinned Newt of the west coast is a muted brown color with a yellow-orange belly.

Fallen Leaves

The forest floor is littered by leaves shed to the ground by storms, disease and the annual autumn process.

As they weather, color fades to earthy browns — sienna, umber, ochre and muted violet.

outer shape

Vine Maple

Cadmium Yellow Med. & Gamboge

② Lay down flat, varied washes. Let dry.

Sap Green

① First define the general outer leaf shape. Then draw the leaf points to correspond to that shape.

③ Add more colored washes to define and age the leaf. Texture with spatter, water spots, etc. Allow the preliminary washes to show through here and there.

Burnt Sienna

Sap Green & Violet

④ Finish with colored pen work. Brown & Payne's Gray Stippling will add an aged, moldering look.

Original Alder leaf shape

Dry leaves curl inward, becoming brittle. Eventually they will crumble and return to the soil.

Contour pen strokes add a smooth, stiff appearance to curled, dry leaves.

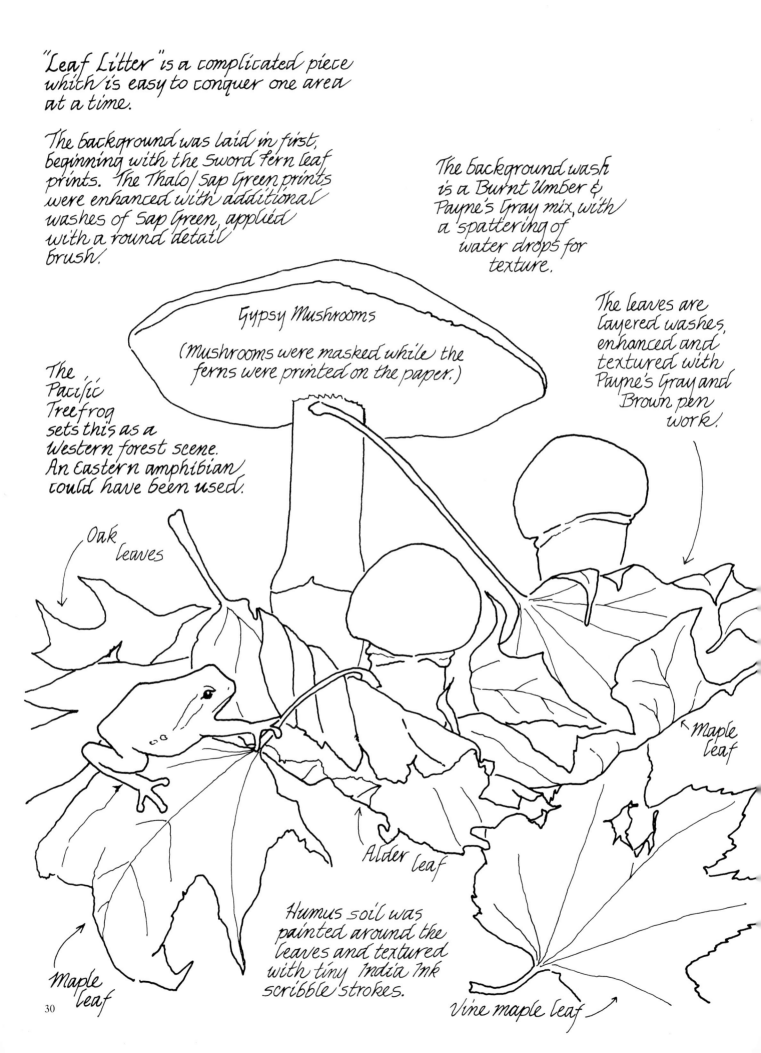

"Leaf Litter" is a complicated piece which is easy to conquer one area at a time.

The background was laid in first, beginning with the Sword Fern leaf prints. The Thalo/Sap Green prints were enhanced with additional washes of Sap Green, applied with a round detail brush.

The background wash is a Burnt Umber & Payne's Gray mix, with a spattering of water drops for texture.

The leaves are layered washes, enhanced and textured with Payne's Gray and Brown pen work.

Gypsy Mushrooms

(Mushrooms were masked while the ferns were printed on the paper.)

The Pacific Treefrog sets this as a Western forest scene. An Eastern amphibian could have been used.

Oak leaves

Maple leaf

Maple leaf

Alder leaf

Humus soil was painted around the leaves and textured with tiny India Ink scribble strokes.

Vine maple leaf

30

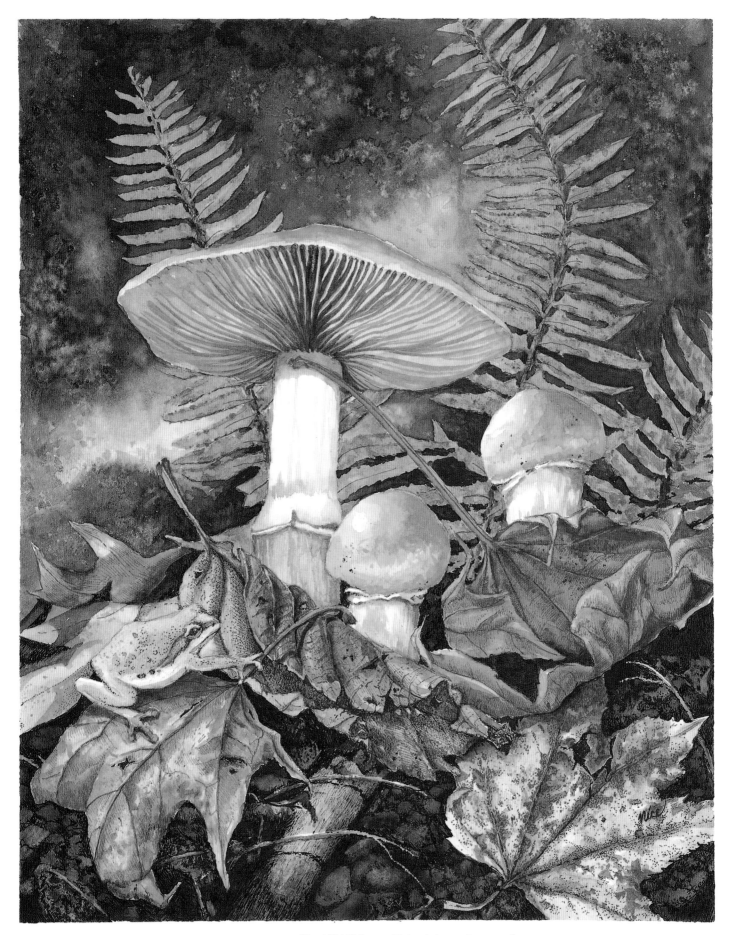

LEAF LITTER, 8″×10″ (20.3cm×25.4cm), layered watercolor
washes textured with spattering, stippling and penwork

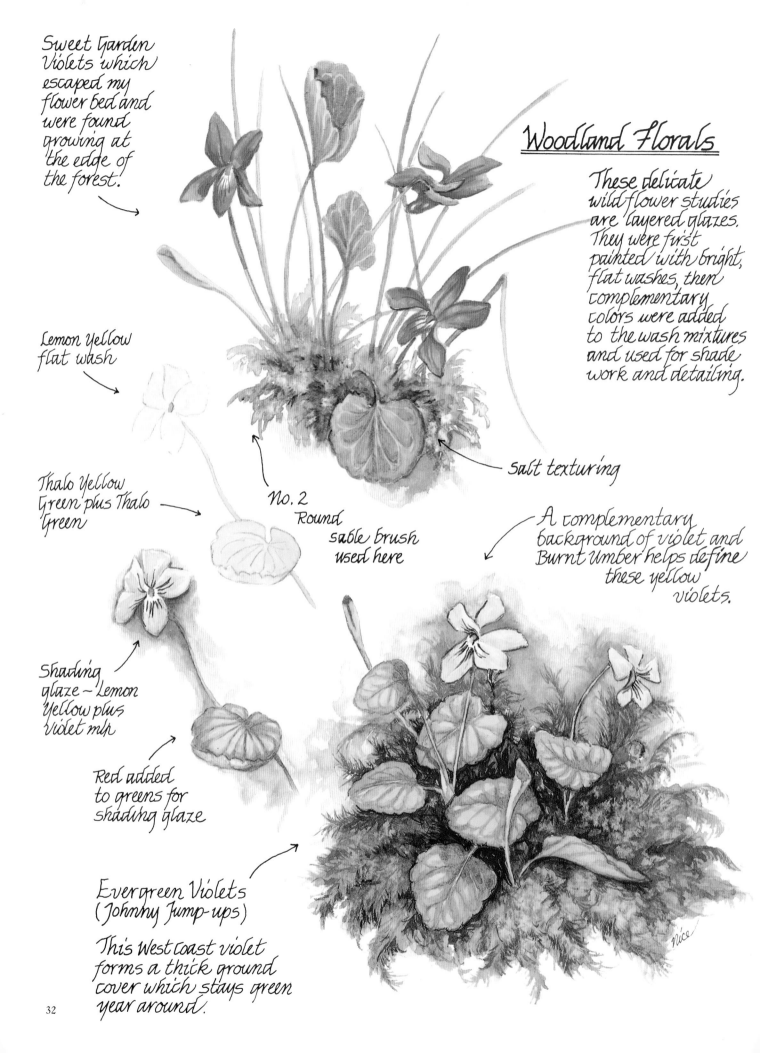

Sweet Garden Violets which escaped my flower bed and were found growing at the edge of the forest.

Lemon Yellow flat wash

Thalo Yellow Green plus Thalo Green

No. 2 Round sable brush used here

Shading glaze - Lemon Yellow plus Violet mix

Red added to greens for shading glaze

Evergreen Violets (Johnny Jump-ups)

This West Coast violet forms a thick ground cover which stays green year around.

Woodland Florals

These delicate wild flower studies are layered glazes. They were first painted with bright, flat washes, then complementary colors were added to the wash mixtures and used for shade work and detailing.

salt texturing

A complementary background of violet and Burnt Umber helps define these yellow violets.

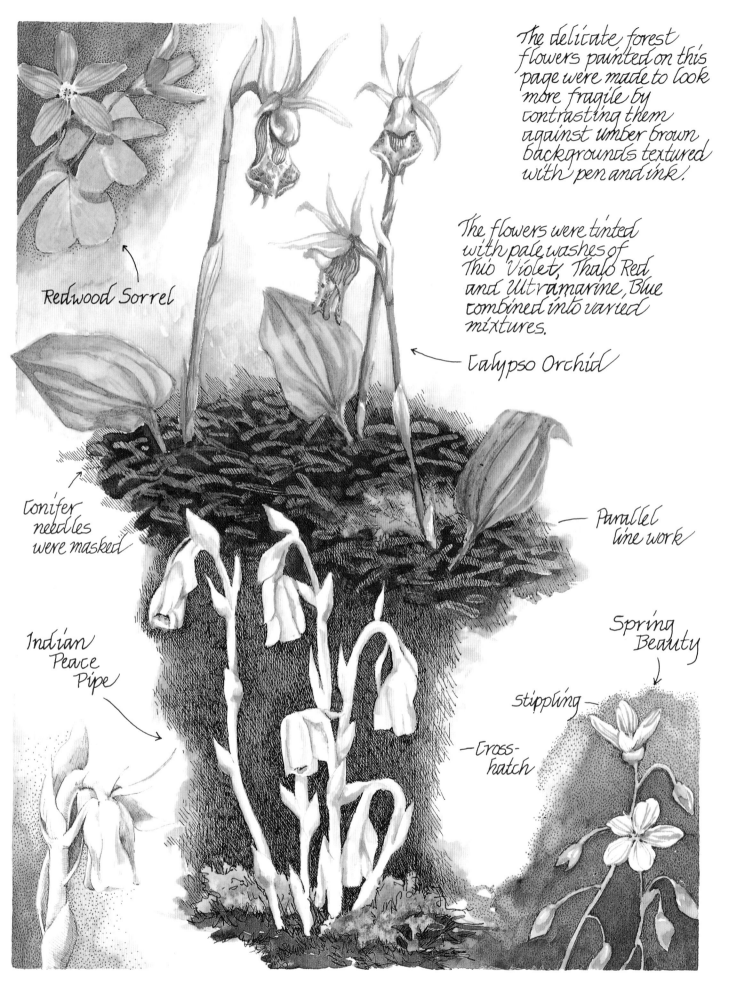

The delicate forest flowers painted on this page were made to look more fragile by contrasting them against umber brown backgrounds textured with pen and ink.

The flowers were tinted with pale washes of Thio Violet, Thalo Red and Ultramarine Blue combined into varied mixtures.

Redwood Sorrel

Calypso Orchid

Conifer needles were masked

Parallel line work

Indian Peace Pipe

Spring Beauty

stippling

Cross-hatch

33

Bunchberry

Wild Geranium

Jack-In-The-Pulpit

Tiger Lily

As seen in these close-up studies, forest flowers make excellent miniature groupings. The blossoms and leaves were painted using layered, blended washes. The textured backgrounds are varied watercolor washes, (some were salted), over laid with stippled pen work in brown or India ink. (.25, .35)

Note that the florals are drawn a little larger than life, completely filling their frames. This creates interesting negative spaces in the background.

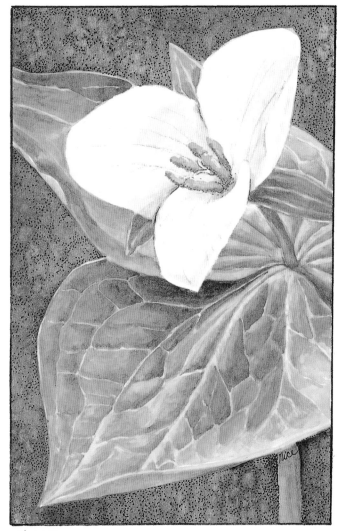

Trillium

Oregon Grape

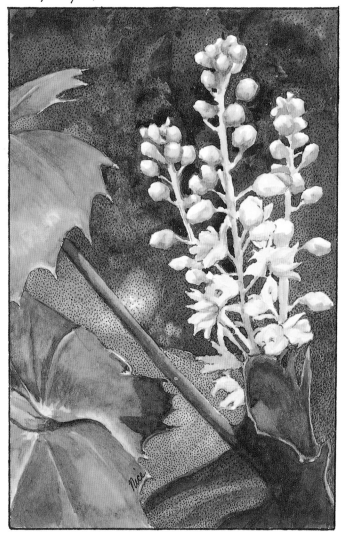

Poison Delphinium

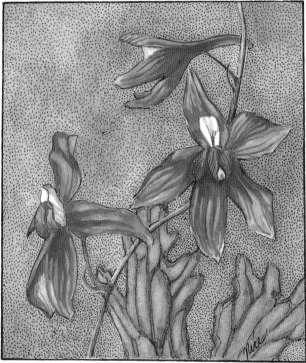

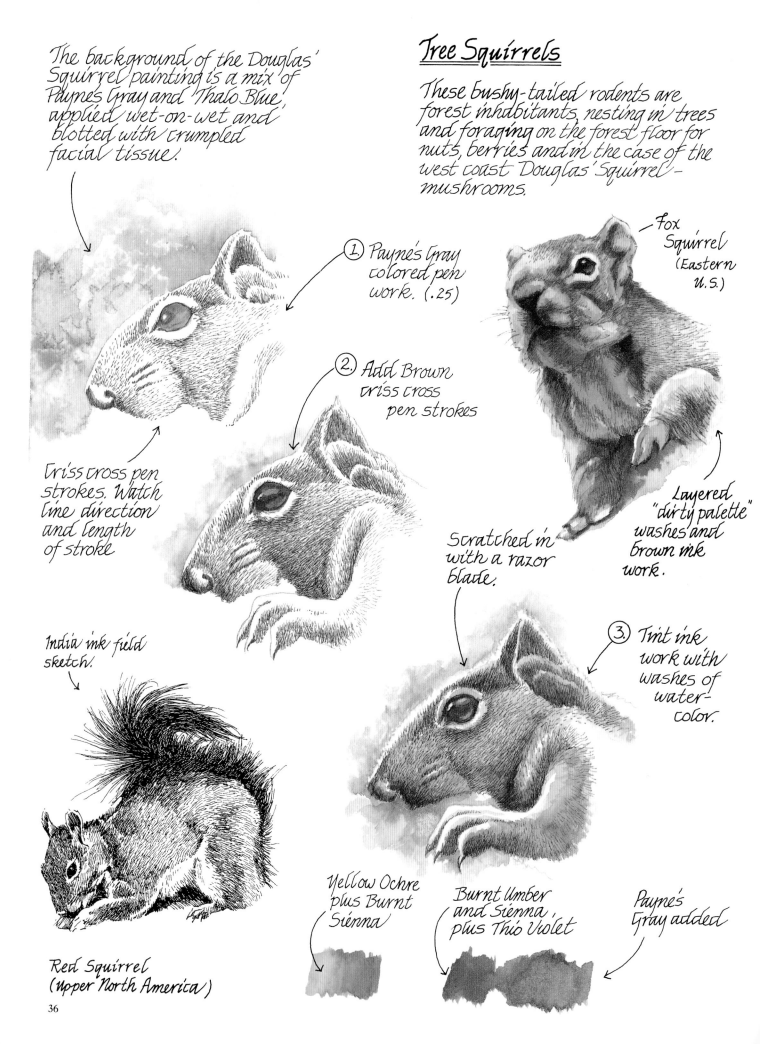

The background of the Douglas' Squirrel painting is a mix of Paynes Gray and Thalo Blue, applied wet-on-wet and blotted with crumpled facial tissue.

Tree Squirrels

These bushy-tailed rodents are forest inhabitants, nesting in trees and foraging on the forest floor for nuts, berries and in the case of the west coast Douglas' Squirrel - mushrooms.

Fox Squirrel (Eastern U.S.)

① Payne's Gray colored pen work. (.25)

② Add Brown criss cross pen strokes

Layered "dirty palette" washes and brown ink work.

Criss cross pen strokes. Watch line direction and length of stroke

Scratched in with a razor blade.

③ Tint ink work with washes of water-color.

India ink field sketch.

Red Squirrel (Upper North America)

Yellow Ochre plus Burnt Sienna

Burnt Umber and Sienna, plus Thio Violet

Payne's Gray added

36

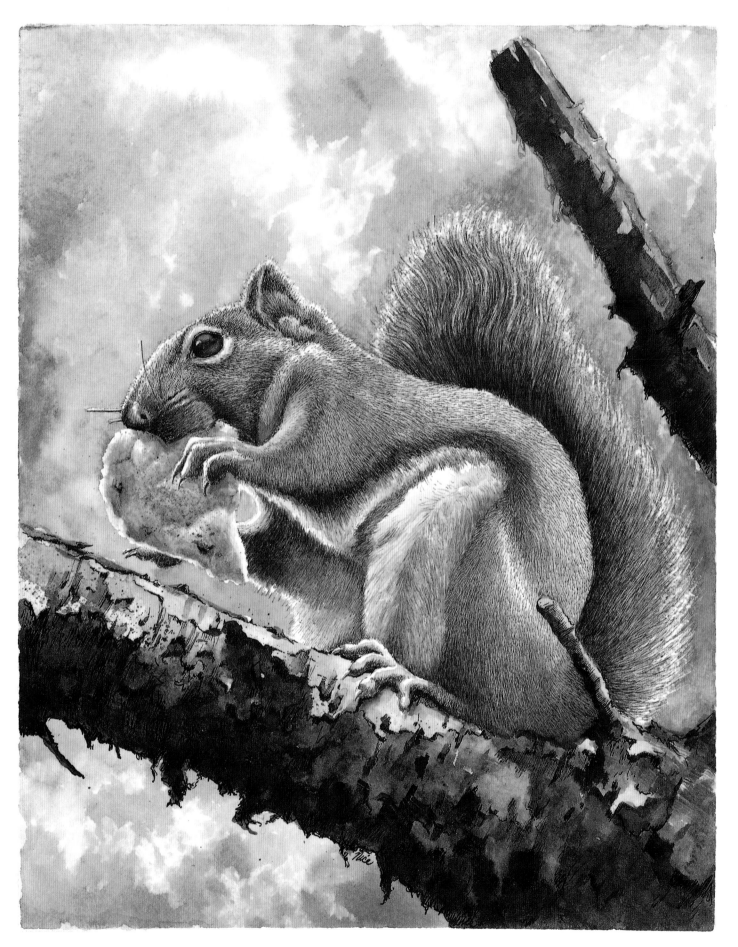

DOUGLAS SQUIRREL, 8″×10″ (20.3cm×25.4cm), colored penwork
tinted with watercolor washes and detailed with India ink

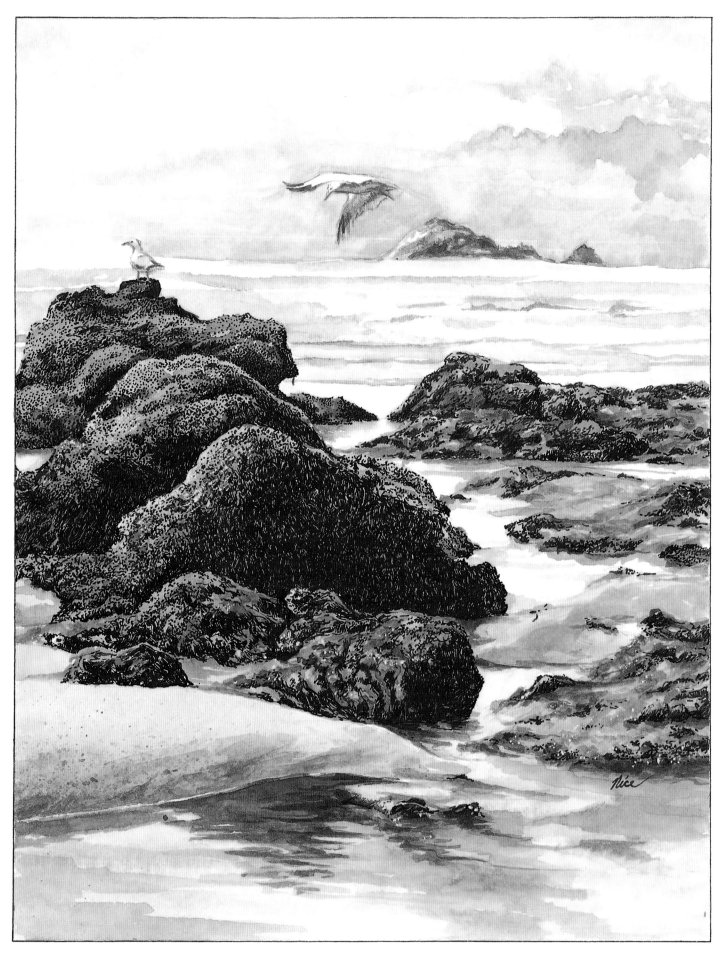

LOW TIDE, 7″×9″ (17.8cm×22.9cm), watercolor washes textured with penwork

TIDE POOLS AND TROPICAL REEFS

It is possible to wear a full smile of delight inside a snorkeling mask. I know, because that's just what happened the first time I donned one and floated into the fantasy world of the tropical reef. I found the water too blue to be believed. Near the surface it undulated in vivid shades of turquoise, changing to cobalt, then deep ultramarine in the shadowy depths. Against this azure backdrop swam wildly patterned fish whose colors were completely uninhibited, as if they had been designed in a creative frenzy by a child with a new box of crayons. In this anything-goes, watery realm, the imagination is set free and artistic license takes on a new meaning. Observation and visual recall are doubly important because on-location sketching is next to impossible. Although my photographs never seem to capture the colors of the reef in accurate splendor, they are valuable in recording shapes, textures and tricky light patterns. Inexpensive, single-use underwater cameras can provide excellent resource material and are effective down to ten feet.

Perhaps you're a landlubber and don't like the idea of swimming with the denizens of the deep, tropical or otherwise. There are alternatives. Most marine aquariums have reef exhibits where the beauty of the undersea world may be enjoyed and sketched in dry comfort. Or check out a pet store specializing in saltwater fish.

Along the rocky coasts, the cold water oceans form their own type of undersea garden: the tide pool. Here, at low tide, the inquisitive explorer can find one visual treasure after another. Seaweeds, anemones, urchins, mollusks and starfish cling to the craggy walls in bright profusion, while tiny crabs scurry over a mosaic floor of broken shells and water-polished pebbles. Tiny fish in sand-colored camouflage dart into the shadows to hide. Always, there's the unexpected: Perhaps you'll spot a fragile jellyfish, trapped by the receding tide. As you walk out among the tide pools, keep the following suggestions in mind. Slip-resistant shoes are a must. Polarized sunglasses will help you see into the pools more clearly. A campstool will add to your comfort if you plan to sketch. Above all, watch the tide—the receding water will return, often with surprising swiftness.

The Reef

Coral colonies consist of small animals (polyps) which surround themselves with a limey material, which in turn hardens into the rigid coral head.

Algae living within the coral provides its coloration of green, brown, ochre, yellow or pinkish tan.

Alcohol spatter

Tropical sea color –

Thalo Green & Thalo Blue

(Graded wash)

Dead, eroded coral spire was painted with a wet-on-wet varied wash, then impressed with plastic wrap.

(Protect background with a paper or film stencil during the procedure.)

Payne's Gray added to Thalo Green and Blue to suggest shadowy, distant reef formation.

Yellow Ochre, daubed with earthy browns.

Live coral head was painted with a wet-on-wet varied wash of Yellow Ochre, Burnt Sienna and Burnt Umber.

India ink stipple work (.25, 50)

Texture was added with spatter, and Brown and Sepia pen work. (.25, .35)

Stippled edge

Besides numerous coral types, there are an overwhelming variety of sponges, sea feathers, fan worms, sea anemones etc. clinging to the reef, each adding a bit of frilly texture and color. To represent them at a distance, try the following technique:

Puddingwife (juvenile)

Fish eye and spots were darkened with India ink.

① Repeating the colors of the fish and sea water, paint a patch work design over the reef area. Work on a dry surface and let the results dry completely before continuing.

This large Wrasse fish inhabits rock and coral reefs from North Carolina to Brazil.

② Working in small sections, layer on a thin, dark wash. (Varied mixes of Siennas, Umbers and Payne's Gray.) Add texture to each area before moving on.

③ Texture by dipping rock salt crystals in water, and laying them into the moist wash. Use tweezers.

④ Leave salt crystals in place until dry, then remove. Darken background areas if needed and stipple them with sepia or India ink. (.25, .35)

Note: Table salt may be used to represent smaller or more distant reef creatures.

Reef Fish

Like sea going butterflies, the reef fish come in an amazing assortment of shapes and colors, each with its own life-style and peculiar habits. Bright, primary colors are at home on these fish, contrasted with blue blacks, dark earthy browns and complementary mixtures.

Most of these fish are Hawaiian inhabitants unless otherwise noted.

Long-nose Butterfly fish 6"

① Preliminary sketch

② Base flat washes are laid in.

③ Scales are blotted in with a paper towel.

Ornate Butterfly fish 7"

Detail brush work

Bluestripe Butterfly fish 5"
(scales depicted with pencil cross hatching)

Foureye Butterfly fish (Atlantic-Gulf of Mexico) 6"

Pen work

Moorish Idol 7"

Ink work

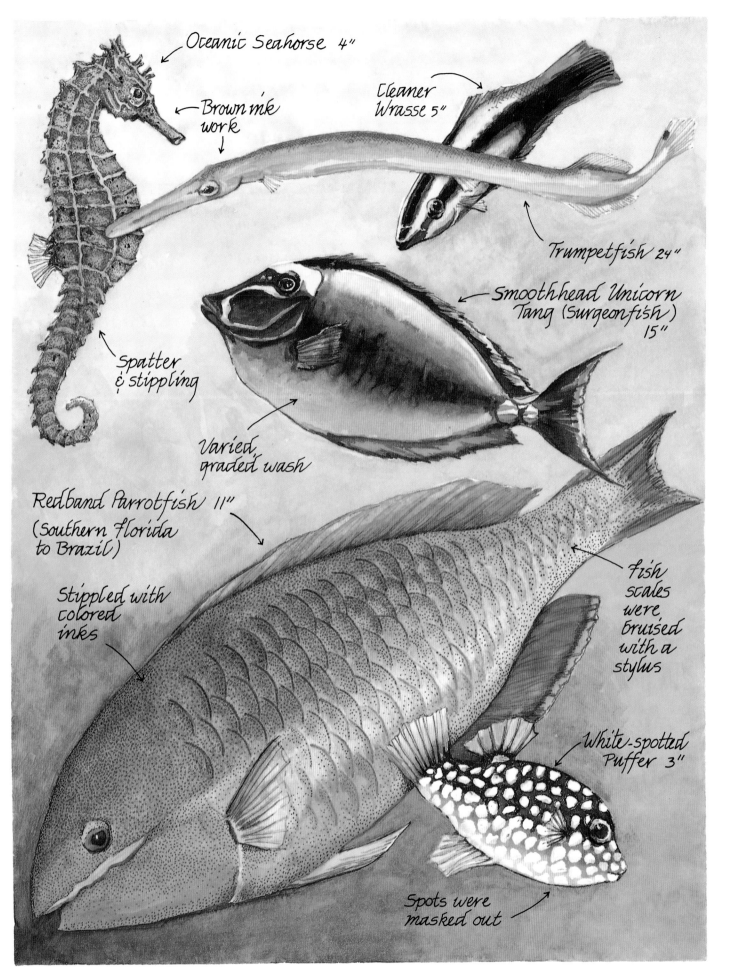

Oceanic Seahorse 4"

Brown ink work

Cleaner Wrasse 5"

Trumpetfish 24"

Smoothhead Unicorn Tang (Surgeonfish) 15"

Spatter & stippling

Varied graded wash

Redband Parrotfish 11" (Southern Florida to Brazil)

Stippled with colored inks

fish scales were bruised with a stylus

White-spotted Puffer 3"

Spots were masked out

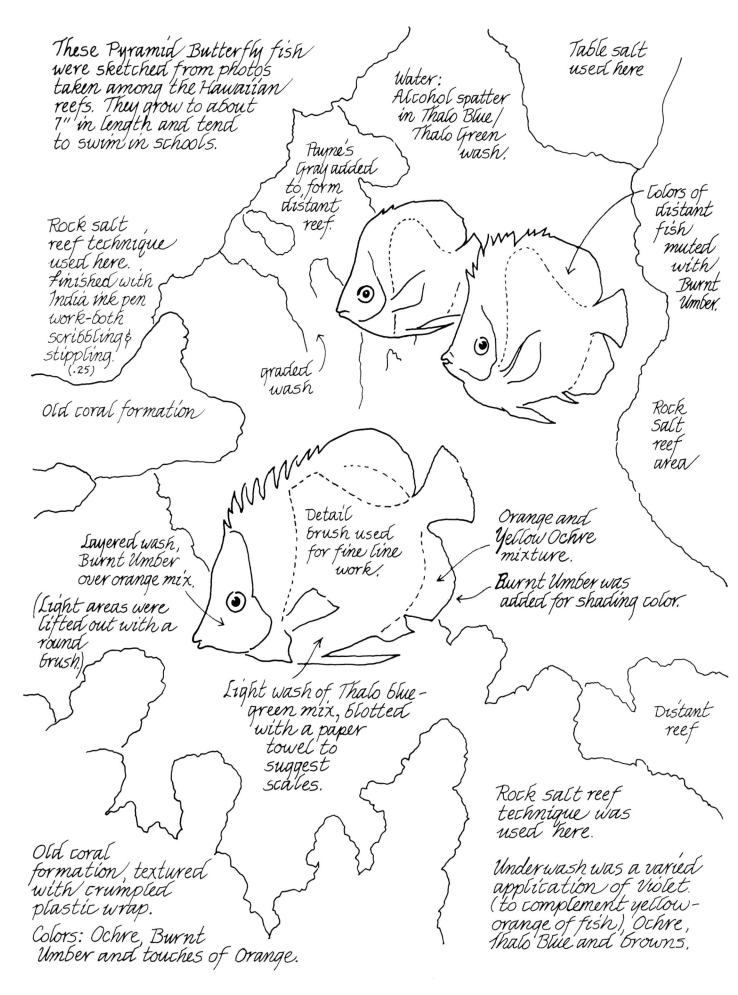

These Pyramid Butterfly fish were sketched from photos taken among the Hawaiian reefs. They grow to about 7" in length and tend to swim in schools.

Water: Alcohol spatter in Thalo Blue/Thalo Green wash.

Table salt used here

Payne's Gray added to form distant reef.

Colors of distant fish muted with Burnt Umber.

Rock salt reef technique used here. finished with India ink pen work—both scribbling & stippling. (.25)

graded wash

Old coral formation

Rock salt reef area

Layered wash, Burnt Umber over orange mix.

(Light areas were lifted out with a round brush.)

Detail brush used for fine line work.

Orange and Yellow Ochre mixture.

Burnt Umber was added for shading color.

Light wash of Thalo blue-green mix, blotted with a paper towel to suggest scales.

Distant reef

Old coral formation, textured with crumpled plastic wrap.
Colors: Ochre, Burnt Umber and touches of Orange.

Rock salt reef technique was used here.

Underwash was a varied application of Violet. (to complement yellow-orange of fish), Ochre, Thalo Blue and browns.

44

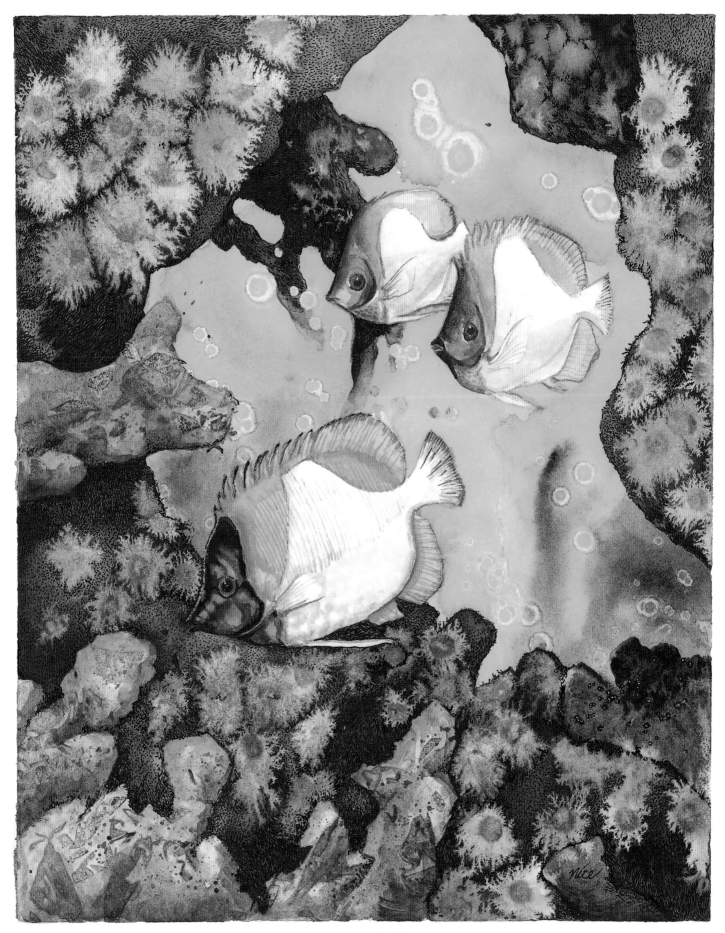

PYRAMID BUTTERFLY FISH, 8″×10″ (20.3cm×25.4cm), water-
color with salt and alcohol techniques and pen and ink stippling

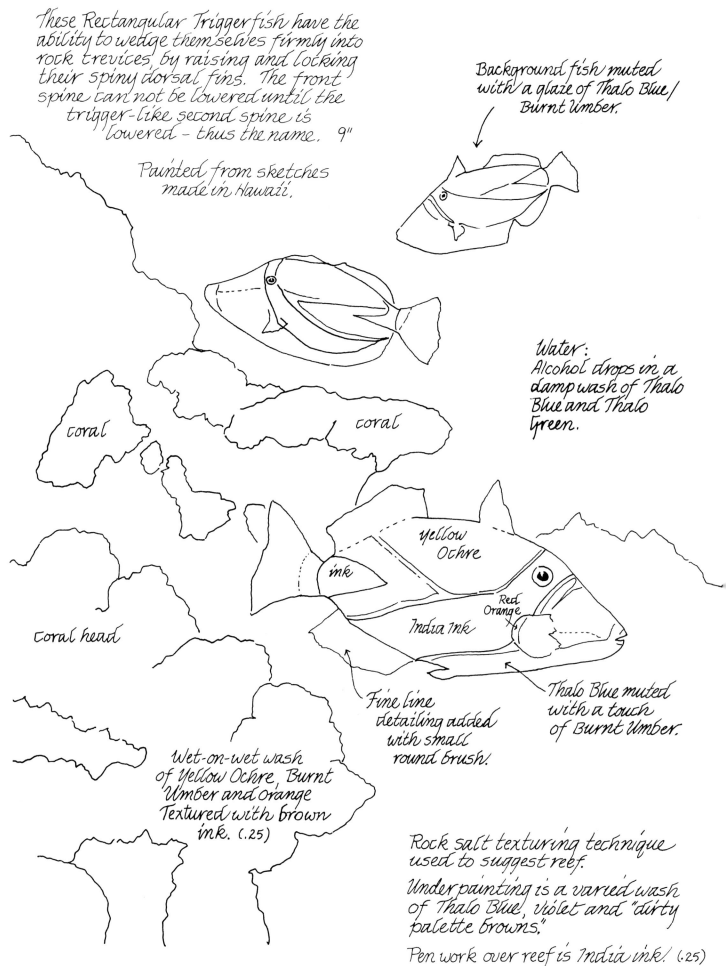

These Rectangular Triggerfish have the ability to wedge themselves firmly into rock crevices, by raising and locking their spiny dorsal fins. The front spine can not be lowered until the trigger-like second spine is lowered - thus the name. 9"

Painted from sketches made in Hawaii.

Background fish muted with a glaze of Thalo Blue/Burnt Umber.

Water: Alcohol drops in a damp wash of Thalo Blue and Thalo Green.

coral

coral

coral head

yellow Ochre

ink

India Ink

Red Orange

Thalo Blue muted with a touch of Burnt Umber.

Fine line detailing added with small round brush.

Wet-on-wet wash of Yellow Ochre, Burnt Umber and orange Textured with brown ink. (.25)

Rock salt texturing technique used to suggest reef.

Under painting is a varied wash of Thalo Blue, violet and "dirty palette browns."

Pen work over reef is India ink. (.25)

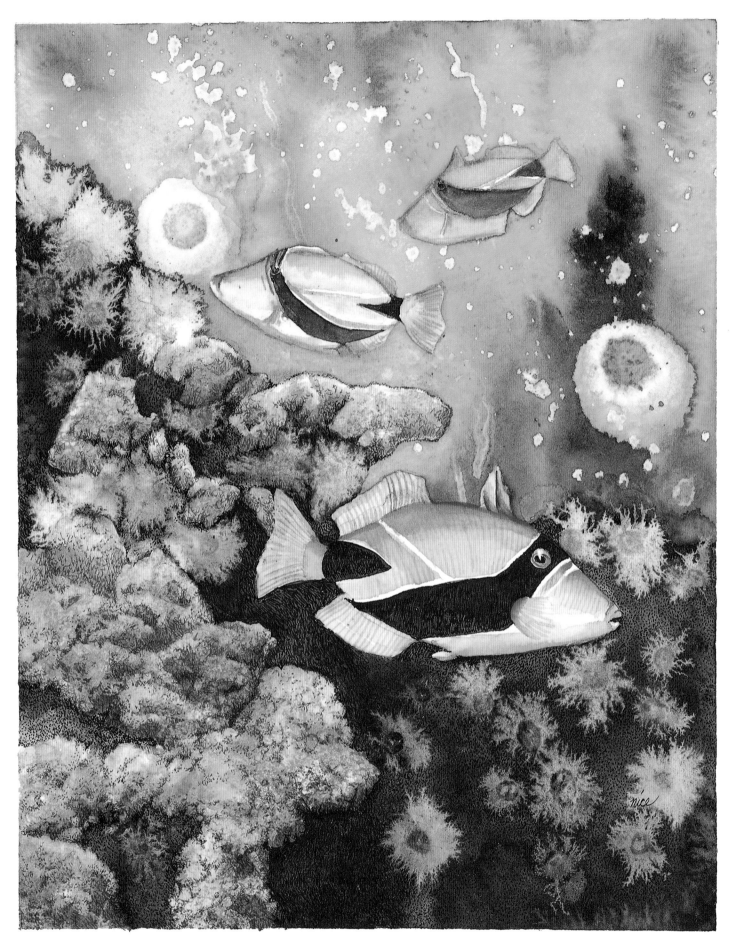

TRIGGERFISH, 8″ × 10″ (20.3cm × 25.4cm), water-
color with salt and alcohol techniques and penwork

Tide Pool Backgrounds

Tide pools are found on rocky shores, in the inter tidal zone, where the relentless surf and sea life carve holes in the stone, and the tides ebb and flow, filling them with sea water and sea debris — sand, fine gravel, smooth pebbles and bits of broken shell.

sand

(A) Lay down a varied wash, (Payne's Gray, Burnt Umber, and dirty palette browns), over a fine spattering of masking fluid.

(B) Texture with fine water color spatter. Remove masking and add pen stippling as needed. (.25)

Pebbles and shell pieces

Use grays, browns and muted hues from the composition.

Mask out white areas.

(1) Use small stroke brush to rough in rounded shapes on a dry surface.

(2) Darken crevices with pen and ink!

(3) Shade with detail brush.

Encrusting Coral Algae forms bright pink calcium scales on rocks, in lower inter tidal pools.

Payne's Gray & Burnt Umber mixtures.

Alcohol spatter

Coralline Algae (Layered washes of Burnt Sienna & Brown Madder.)

Encrusting Creatures

Clinging tenaciously to wave-swept rocks are leaf barnacles, common barnacles and mussels, forming thick crusty colonies. On top crawl the snails and limpets, feeding on algae. Pen and ink works well to depict these highly textured animals. A light wash of watercolor will bring them to life.

(.25)

Leaf Barnacle
(west coast)

California mussel
(west coast)

Blue
Mussel
(both coasts)

Northern
Rock Barnacle
(Northeast coast)

Sepia ink

Barnacle quick
studies in gray
ink

Cayenne
Keyhole Limpet
Volcano Limpet
(below)

Atlantic
Dogwinkles

Unicorn

Beaded
Miter
(east coast)

Emarginate
Dogwinkle

Black
Turban
Snail
(Algae on
shell)

West
coast

49

Crabs

The crabs living in the intertidal zone are small, with earth tone shells that match their surroundings. Sponging provides a fun way to depict their rough, crusty texture.

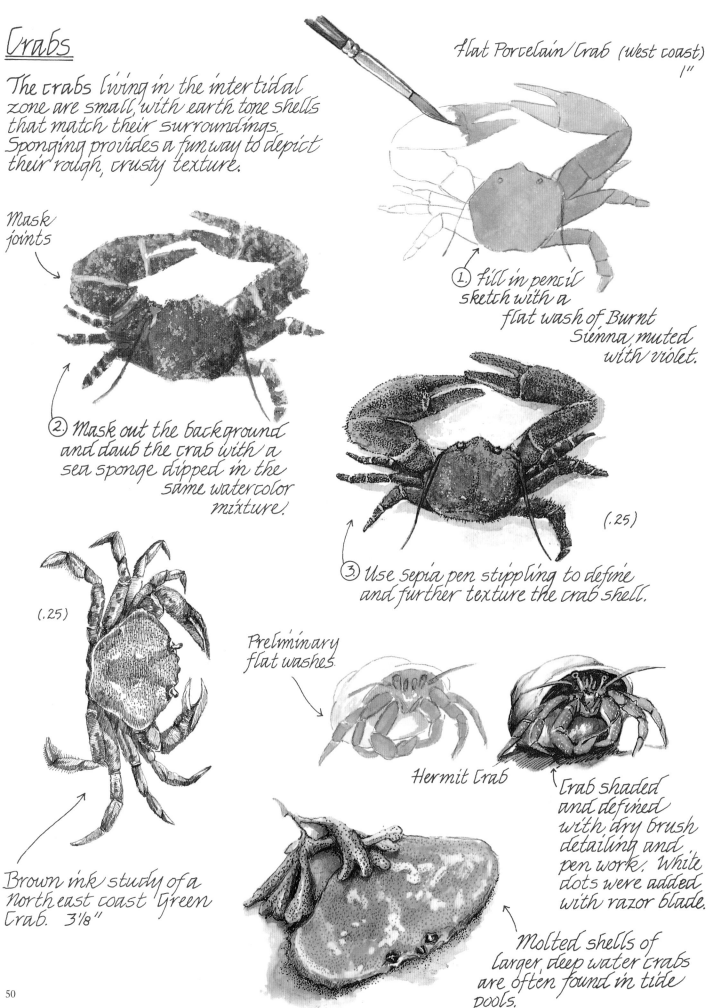

Flat Porcelain Crab (west coast)
1"

① fill in pencil sketch with a flat wash of Burnt Sienna, muted with violet.

Mask joints

② Mask out the background and daub the crab with a sea sponge dipped in the same watercolor mixture.

(.25)

③ Use sepia pen stippling to define and further texture the crab shell.

(.25)

Preliminary flat washes

Hermit Crab

Brown ink study of a North east coast Green Crab. 3⅛"

Crab shaded and defined with dry brush detailing and pen work. White dots were added with razor blade.

Molted shells of larger deep water crabs are often found in tide pools.

Sea Stars And Urchins

Sea stars and urchins are closely related, both having a spiny shell and tiny tube feet. Their color range includes brown, green, purple and red. Sea stars can also be pink, ochre and bright orange. They inhabit rocky walls in tide pools and deeper.

Sand dollars prefer sand bottoms, and are seldom found alive in tide pools.

① Pencil sketch

Spines net like

② Mask out spines in a dotted pattern and brush on a flat wash.

Ochre Sea Star (West coast)

③ shade the sea star with pen stippling and blended washes of the same mixture, darkened.

← Northern Sea Star (North east coast)

Row of spines down center of arm

Purple Sea Urchin

Spines were masked out while body was painted

Dry brush accents

Sand dollar shells, like this Eccentric, are sometimes washed into tide pools and make interesting additions to sketches.

Tentacles are used to capture food.

Sea Anemones

Sea anemones look like symmetrical flowers, but are actually long-lived animals. There are over 1,000 species, ranging from tide pool dwellers to inhabitants of the deep sea trenches. The Giant Green Anemone illustrated on this page colonizes tide pools from Japan, Siberia and Alaska to Panama.

Distant sea anemones can be suggested using rock salt.

① Outline the tentacles lightly in pencil and mask with masking fluid, leaving body area open.

② Paint the body and background areas. Let dry. (A wash of Thalo Green, Thalo Yellow Green and Burnt Sienna, to mute color, was used on the body.)

③ Shade body and add cast shadows with a darker wash mixture.

④ Remove masking fluid with masking tape and tint the tentacles with a very pale wash.

The base is textured with brown ink stippling.

The fish is a Tide Pool Sculpin!

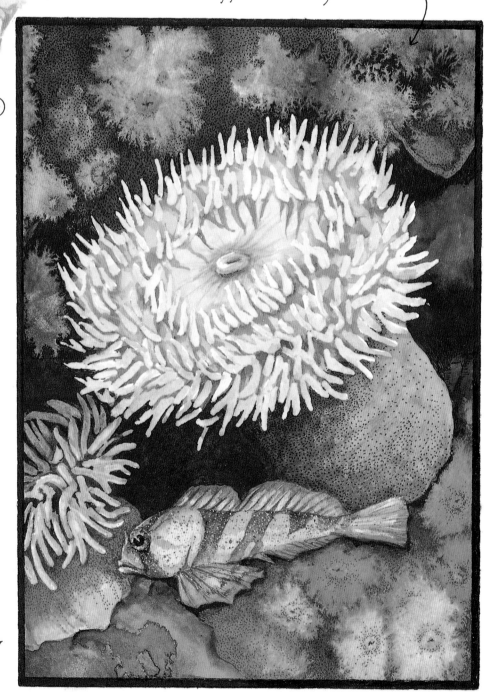

Jellyfish

Sea Jellies don't live in tide pools, but may be swept in during high tide. Depicting their delicate, translucent bodies can be a fun challenge.

The distant jellyfish on either side began with a large drop of alcohol, dropped on a moist surface wash. Brushed alcohol streamers were added to the jelly on the right.

Detailing was a combination of razor blade scratches, dip pen applied white ink and white acrylic paint.

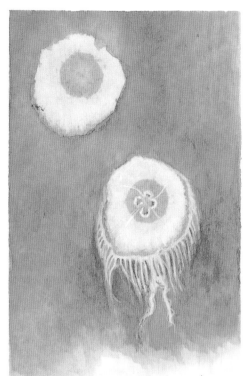

Moon Jellyfish
(top view)

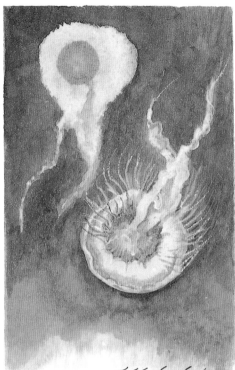

Moon Jellyfish
(bottom view)

For transparent look, let background color show through body.

This delicate, ruffled Sea Nettle was painted in a series of pale, layered washes. The reddish tentacles were masked and painted last. Most important - Stop before it gets over worked!

The dark, ink textured water sets it off.

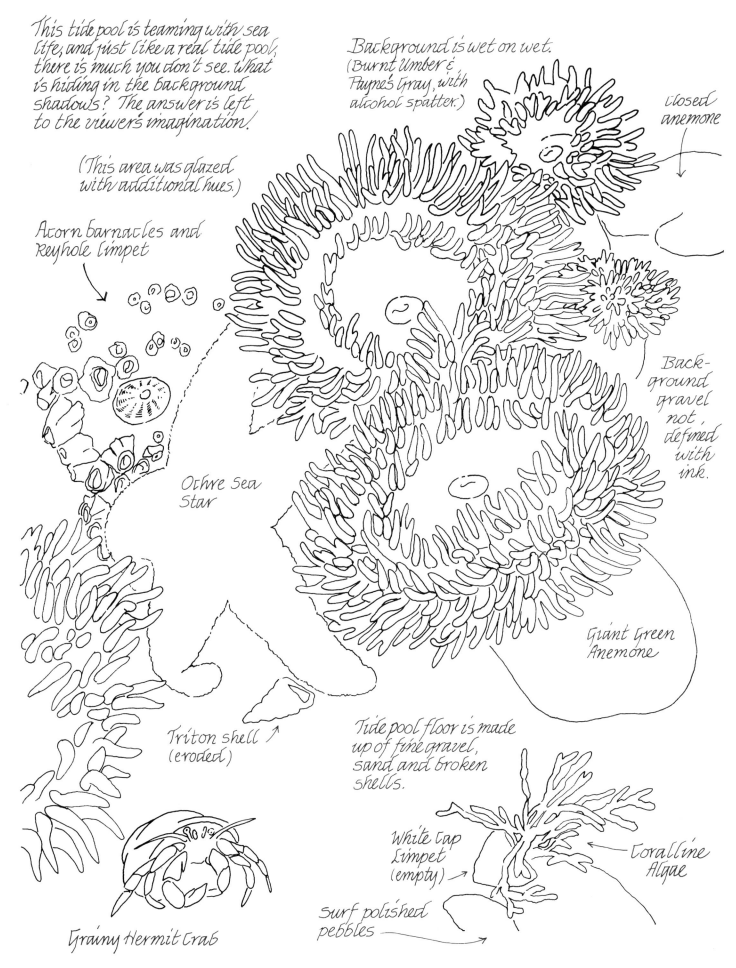

This tide pool is teaming with sea
life, and just like a real tide pool,
there is much you don't see. What
is hiding in the background
shadows? The answer is left
to the viewer's imagination!

(This area was glazed
with additional hues.)

Background is wet on wet.
(Burnt Umber &
Payne's Gray, with
alcohol spatter.)

Closed
anemone

Acorn barnacles and
Keyhole Limpet

Background
gravel
not
defined
with
ink.

Ochre Sea
Star

Giant Green
Anemone

Triton shell ↗
(eroded)

Tide pool floor is made
up of fine gravel,
sand and broken
shells.

White Cap
Limpet
(empty) →

Coralline
Algae

Surf polished
pebbles ———

Grainy Hermit Crab

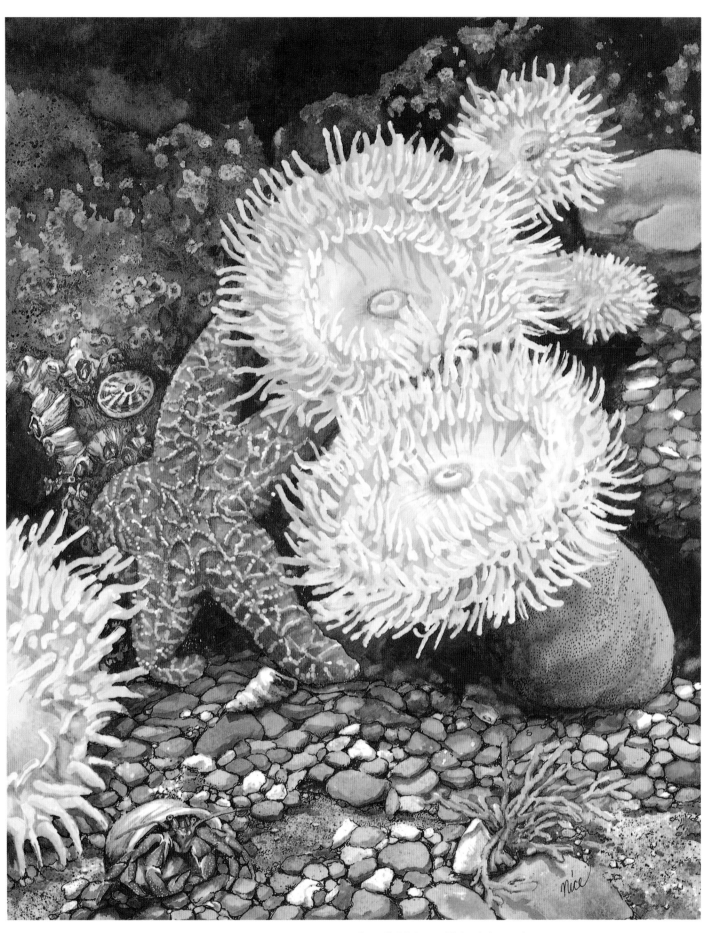

TIDE POOL TERRITORY, 8″×10″ (20.3cm×25.4cm), layered
watercolor washes textured with penwork and spatter

Green Seaweeds

These large algae plants are abundant in the tidal areas where they cling to rocks, shells and other solid objects. Their shapes and textures vary greatly, allowing the use of numerous techniques in their portrayal.

Sepia ink scribble lines

The flat Sap Green wash was scraped with a small chisel when it was near dry.

Surf Grass
Dry brushed with a no. 4 round brush.

Sea Lettuce

Thin, lettuce-like plants that live in the upper intertidal zone on both coasts.

Layered wash of Sap Green and Burnt Umber.

Sugar Wrack (both coasts)
A kelp with blades of up to 2 feet in length.

Rockweeds (both coasts)
These thin, rubbery plants have swollen tips.

Sea Sack (west coast)
Hollow, thin-walled plants filled near the top with gas. May be yellow green to purplish.

Graded wash

contour lines

Thalo Blue, Payne's Gray and Burnt Umber

Ochre and Sap Green

"Incoming Tide" (opposite) captures the exact moment the sea returns to the rocks, seaweed and barnacles. This is a complete pen and ink drawing, to which water color washes were added. The white water was protected with masking fluid.

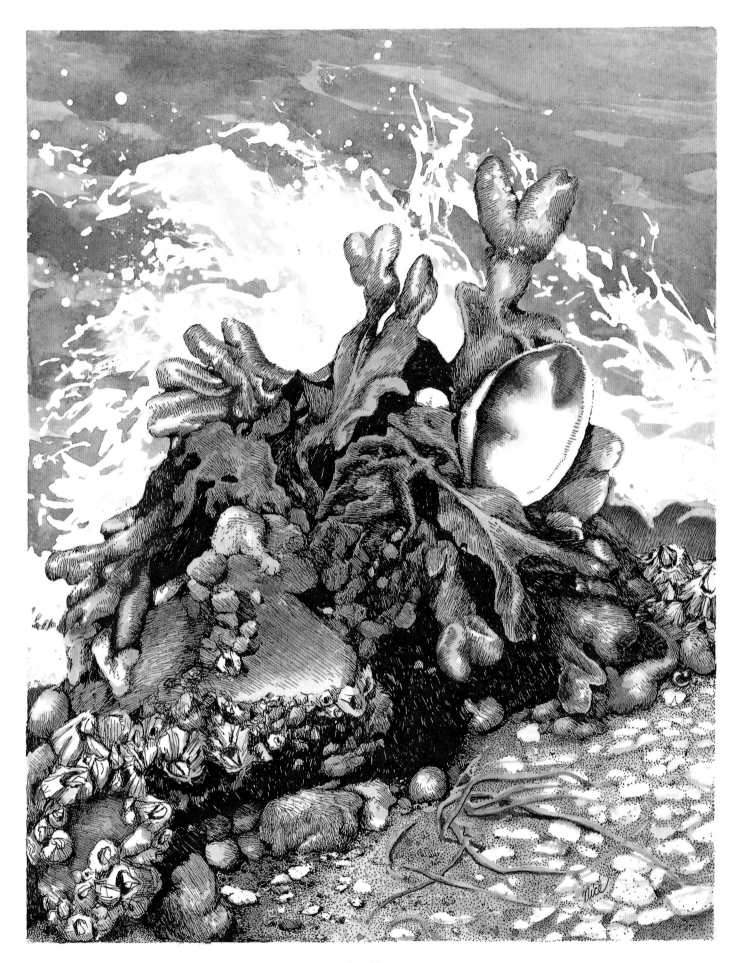

INCOMING TIDE, 7″ × 9½″ (17.8cm × 24.1cm),
Pen and ink drawing tinted with watercolor washes

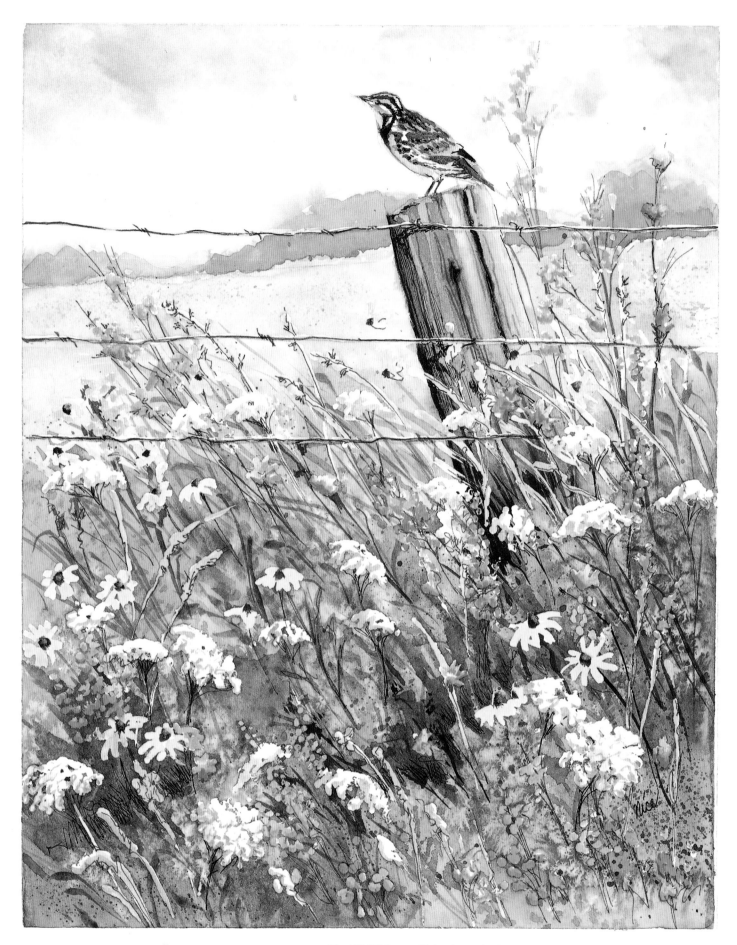

MEADOWLARK, 8″×10″ (20.3cm×25.4cm), masked
flowers, watercolor wash and Sepia ink detailing

FIELDS OF FLOWERS

Like a bright patchwork quilt cast across a bed, the spring wildflowers ripple across the face of the prairie, dancing in the dappled light of the forest meadows and meandering gaily through the open countryside to celebrate the sun. Wherever there are open fields, there are wildflowers. Some blossoms are bold with carnival-bright colors, while others are shy, hiding among the grasses in subtle pastel dress. All are beautiful. In nature's garden, there are no weeds—each plant has a purpose. Each bud, blossom, leaf and seed is a potential subject for the sketchbook.

In the field, the flowers have a vitality that cannot be duplicated in the studio with cut flowers. The still life is just that—still—the life force beginning to ebb from the blossoms.

Sit awhile among the flowers of the field and notice how the sun plays across the petals, creating a translucent quality not unlike stained glass. The colors are brighter in the natural light, requiring purer color mixtures on your palette. Linger long enough and you will see that the flowers are not the only inhabitants of the fields. The hum of insects and the twitter of the birdsong is all about. A hummingbird may zoom by on an important nectar-finding mission, while butterflies flit among the flowers in a silent ritual.

Wearing the earthy colors of the soil, rabbits, prairie dogs and mice keep watch among the grasses. Don't be afraid to add a creature or two to your flower paintings. They can provide an additional splash of color (butterflies and birds), create a point of interest (creeping insects) or provide earthy contrast hues (small animals). But don't try to draw it all. A simple study, devoid of background, is often more pleasing to the eye than an overwhelming tangle of foliage.

On the following pages the weather is clear, the flowers are in full bloom and the animals are cooperative, so don your sunglasses and join me in the field of flowers.

Drawing The Flower

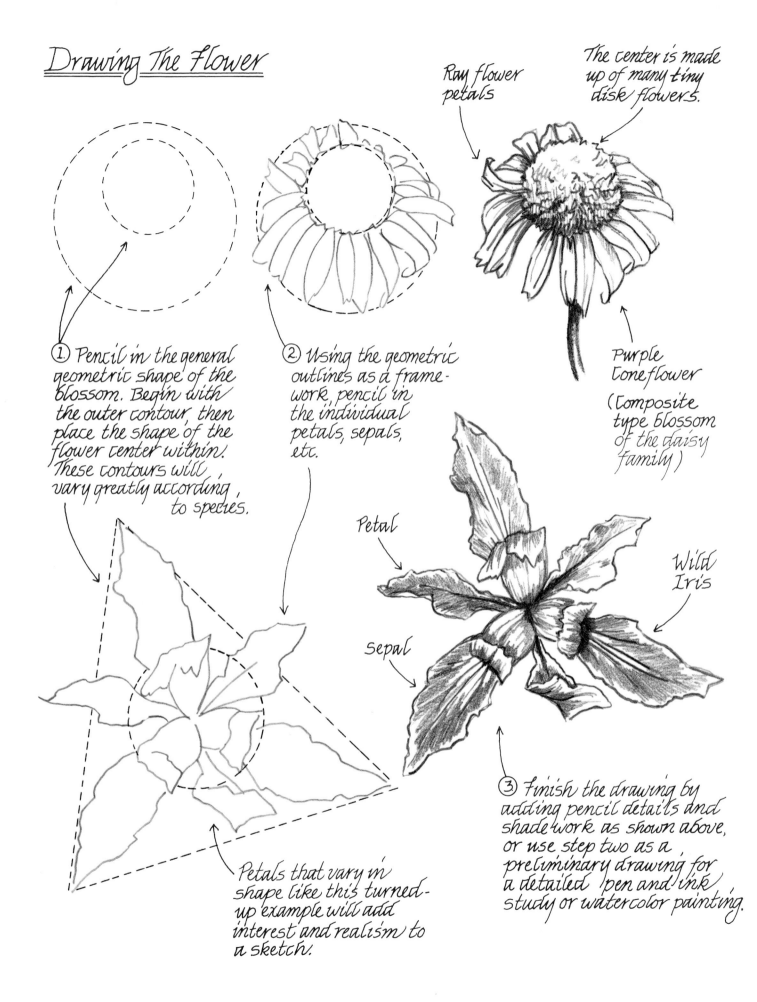

Ray flower petals

The center is made up of many tiny disk flowers.

① Pencil in the general geometric shape of the blossom. Begin with the outer contour, then place the shape of the flower center within. These contours will vary greatly according to species.

② Using the geometric outlines as a framework, pencil in the individual petals, sepals, etc.

Purple Coneflower

(Composite type blossom of the daisy family)

Petal

Sepal

Wild Iris

③ Finish the drawing by adding pencil details and shadework as shown above, or use step two as a preliminary drawing for a detailed pen and ink study or watercolor painting.

Petals that vary in shape like this turned-up example will add interest and realism to a sketch.

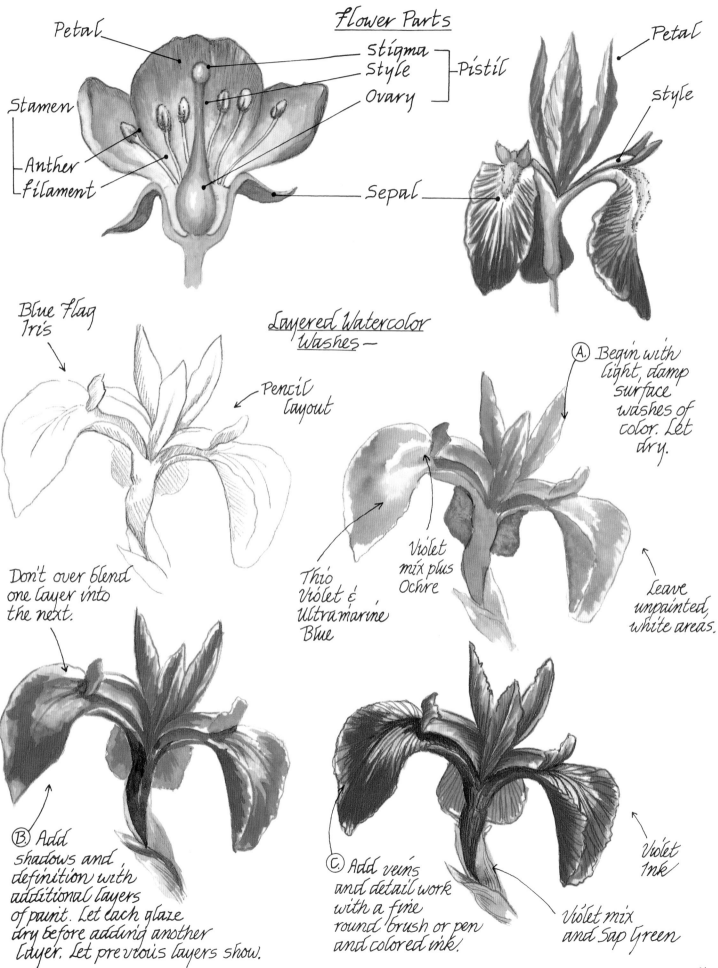

Flower Parts

Petal

Stigma ⎫
Style ⎬ Pistil
Ovary ⎭

Stamen ⎧ Anther
 ⎨ Filament

Petal

Style

Sepal

Layered Watercolor Washes —

Blue Flag Iris

Pencil Layout

A. Begin with light, damp surface washes of color. Let dry.

Thio Violet & Ultramarine Blue

Violet mix plus Ochre

Leave unpainted, white areas.

Don't over blend one layer into the next.

B. Add shadows and definition with additional layers of paint. Let each glaze dry before adding another layer. Let previous layers show.

C. Add veins and detail work with a fine round brush or pen and colored ink.

Violet Ink

Violet mix and Sap Green

More layered-wash
blossoms to experiment
with —

① Pencil in flower
shape and base
wash the ray
petals with
Gamboge.

(Damp surface wash.)

② While the yellow rays
are still moist, paint
the center with Brown
Madder and let it
"bleed" onto the inner
edges of the ray petals.
Let dry.

③ Add Thio Violet to
Gamboge and use
mix to shade and
define ray petals.

Use a second layer
of Brown Madder
to define flower
center.

④ Texture the
flower center
with India
ink scribble
lines.

Ⓐ
Begin painting
with damp surface
washes —

Grumbacher Red & Thio
Violet mixed

Blend
edges

Thalo Yellow
Green

Ⓑ Second
layer is a
Thalo Yellow
Green, Sap
Green & Thalo
Green mix.

Ⓒ Third
layer is
a mix of Thio
Violet / Grumbacher
Red with a touch
of dark green from
step B added.

Ⓓ Fourth layer is
the dark green mi
from step B, with
Grumbacher Red
added.

The edges of
each additional
layer were softened
and blended with a
clean, damp, no. 4 round brush.

Indian
Paintbrush

Some additional
floral techniques ~

An actual rose petal,
painted with Thalo Red
and stamped onto the
paper in a circular
arrangement, forms
a delicate Prairie
Rose print.

Rose center
is Lemon
Yellow/Ochre,
textured with
Brown pen
work.

Sap Green washes and
Green stippled pen
work gives the
petals definition.

Oxeye Daisy

Center of flower
is a damp surface,
varied wash of Sap
Green and Yellow
Ochre, sprinkled
with table salt.

Sunflower

This is a pen and Burnt
Sienna ink drawing
tinted with watercolor.

The dark accents in the
flower center were added
with Sepia Ink.

Early settlers roasted Chicory roots and ground them for use as a coffee substitute.

This whimsical study of a Chicory plant began with a Sap Green wash, "flung" onto the paper with a 1/2" Aquarelle brush.

The resulting spontaneous pattern became the basis for the stem and flower buds.

The petals of the Chicory blossom were painted free hand with a 3/16" wide stroke brush and a watercolor wash of Thio Violet and Ultramarine Blue.

Stray spatter adds to the "wild plant look."

Detail the flower with a no. O round detail brush and the violet mix
or
Use a fine pen and Blue Violet Ink.

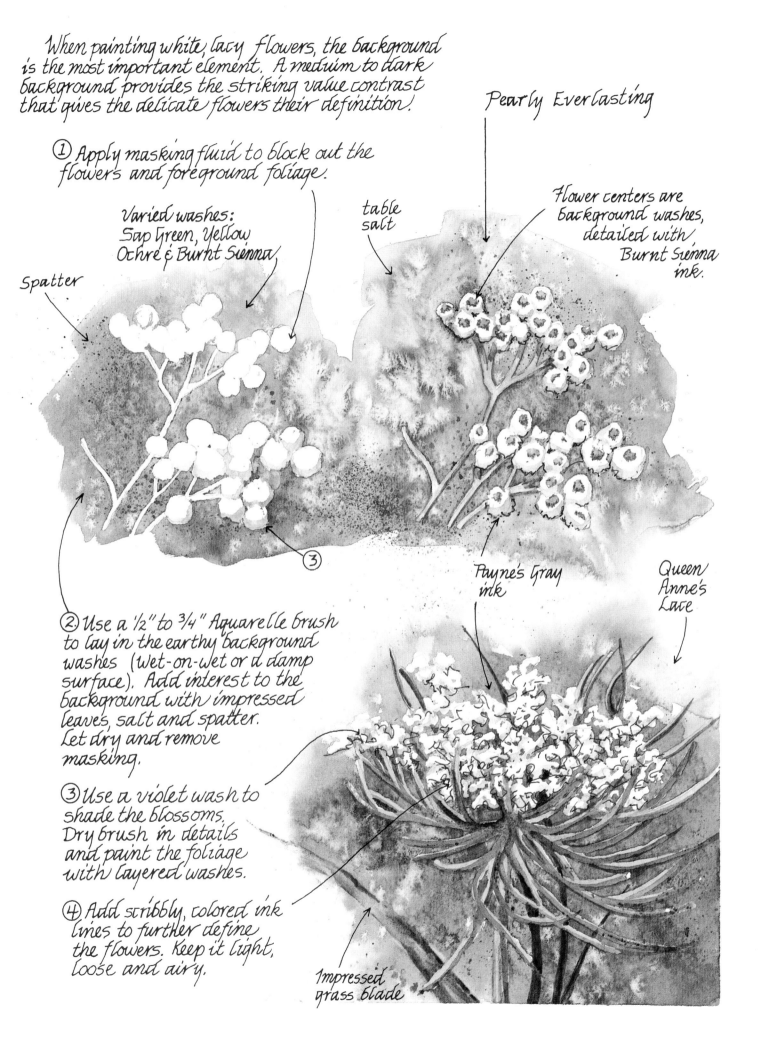

When painting white, lacy flowers, the background is the most important element. A medium to dark background provides the striking value contrast that gives the delicate flowers their definition.

① Apply masking fluid to block out the flowers and foreground foliage.

Varied washes: Sap Green, Yellow Ochre & Burnt Sienna

Spatter

Pearly Everlasting

table salt

Flower centers are background washes, detailed with Burnt Sienna ink.

Payne's Gray ink

Queen Anne's Lace

② Use a ½" to ¾" Aquarelle brush to lay in the earthy background washes (wet-on-wet or a damp surface). Add interest to the background with impressed leaves, salt and spatter. Let dry and remove masking.

③ Use a violet wash to shade the blossoms. Dry brush in details and paint the foliage with layered washes.

④ Add scribbly, colored ink lines to further define the flowers. Keep it light, loose and airy.

Impressed grass blade

Insects

Insects are woven intricately into the floral tapestry of the grasslands. Therefore it is quite natural to include them in flower sketches. Here are some of my favorites.

Honey Bee
(Ochre and varied brown washes, detailed with Brown and India Ink. Yellow pollen was spattered on before pen work.)

American Bird Grasshopper
(Sepia and India Ink pen work, tinted with varied brown washes.)

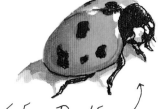

Ladybug Beetle
(Grumbacher Red and Sap Green washes, with India Ink pen work.)

Ground Beetle ———→
(.25, India Ink)

① Begin with a pencil layout, showing wing sections.

② Add pale watercolor washes applied to a very moist surface. Allow natural blending. Let dry.

③ Fill in dark areas with India Ink.
(.25, .50)

Giant Swallowtail

Palette: Lemon Yellow, Ochre, Grumbacher Red and Ultramarine Blue.

Stippling softens wing section edges and helps suggest the individual scales.

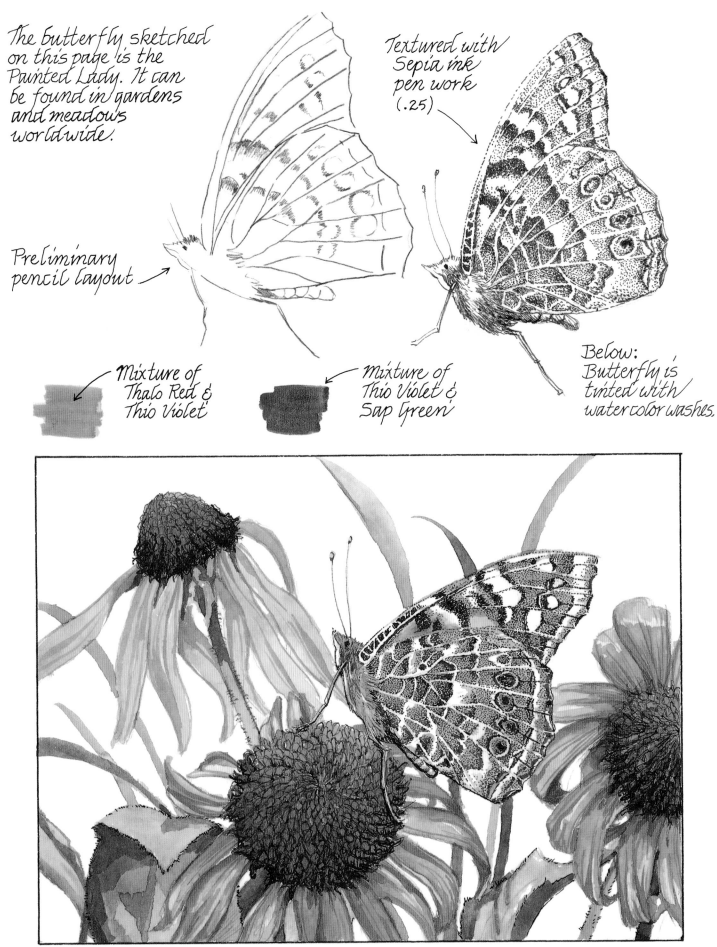

The Butterfly sketched on this page is the Painted Lady. It can be found in gardens and meadows worldwide.

Textured with Sepia ink pen work (.25)

Preliminary pencil layout

Mixture of Thalo Red & Thio Violet

Mixture of Thio Violet & Sap Green

Below: Butterfly is tinted with water color washes.

Blossoms are Purple Coneflowers. Flower centers were textured with Sepia and India Ink scribble lines.

Hummingbirds

No bird is more at home around nectar-rich flowers than the feisty hummingbird. Preferring bright, reddish blossoms like phlox, paintbrush and bee balm, the "hummer" jealously guards his favorite garden patch with angry chatter and dive-bombing displays.

Costa's Hummingbird

The blurry look of wet-on-wet and salt techniques adds a feeling of motion.

Head is large compared to body size.

Long, narrow bill, designed for dipping into tubular blossoms.

Tiny feet allow bird to perch, but not walk.

Feathers were textured with the bruising technique.

Rufous Hummingbirds

These perched "hummers" were loosely sketched using a .25 Rapidograph pen and Sepia ink.

Male

Female

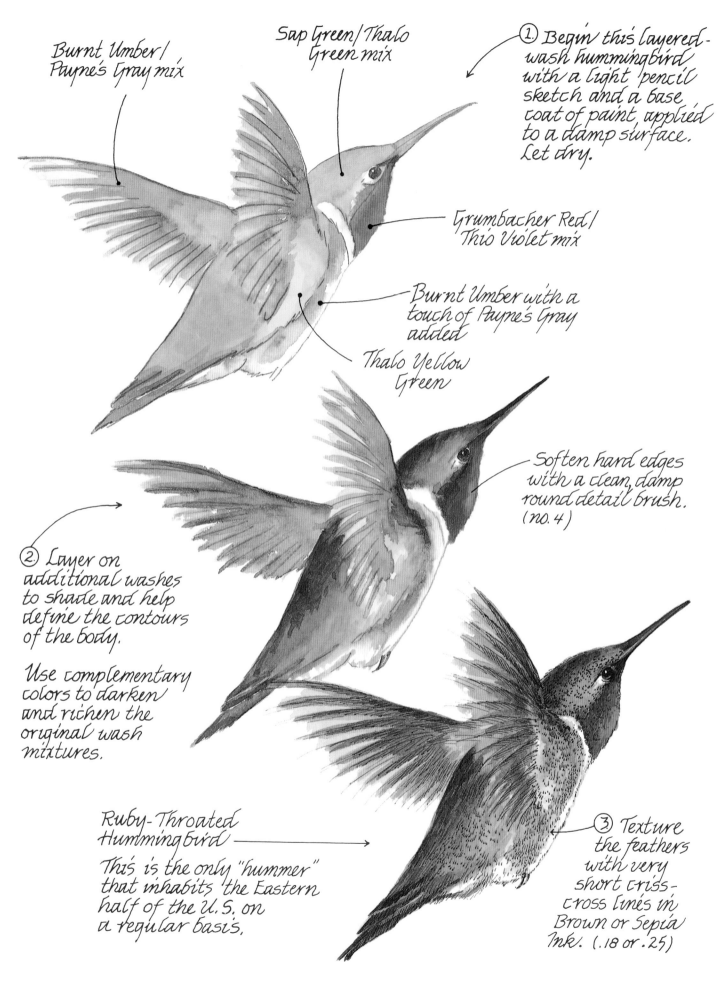

Burnt Umber /
Payne's Gray mix

Sap Green / Thalo
Green mix

① Begin this layered-
wash hummingbird
with a light pencil
sketch and a base
coat of paint, applied
to a damp surface.
Let dry.

Grumbacher Red /
Thio Violet mix

Burnt Umber with a
touch of Payne's Gray
added

Thalo Yellow
Green

Soften hard edges
with a clean, damp
round detail brush.
(no. 4)

② Layer on
additional washes
to shade and help
define the contours
of the body.

Use complementary
colors to darken
and richen the
original wash
mixtures.

Ruby-Throated
Hummingbird

This is the only "hummer"
that inhabits the Eastern
half of the U.S. on
a regular basis.

③ Texture
the feathers
with very
short criss-
cross lines in
Brown or Sepia
Ink. (.18 or .25)

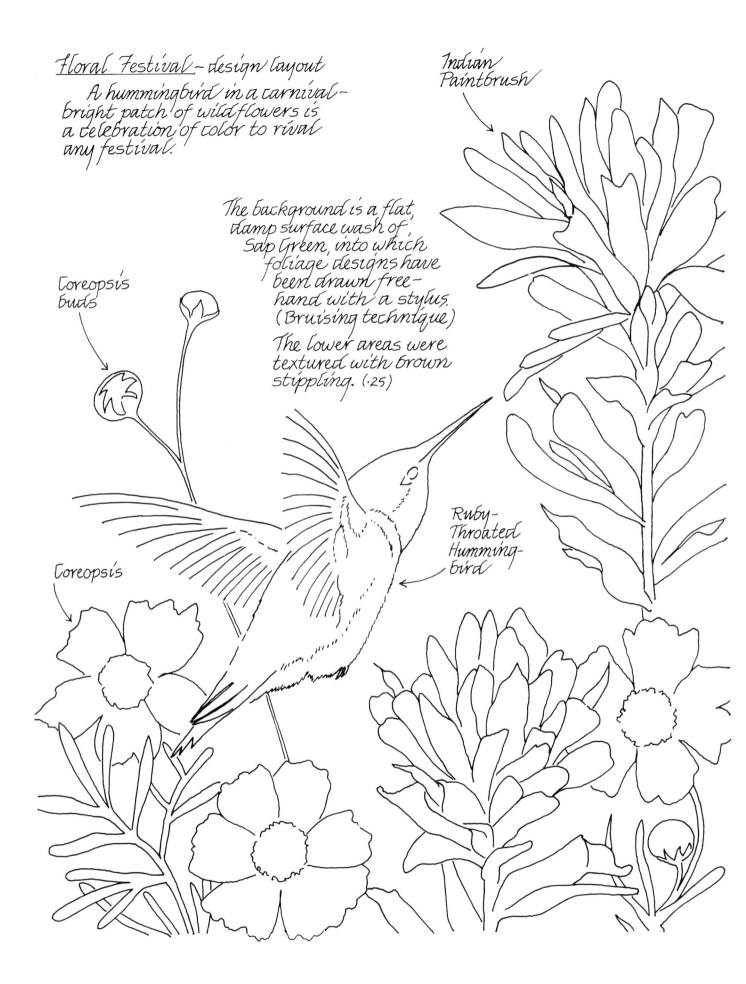

Floral Festival — design layout

A hummingbird in a carnival-bright patch of wildflowers is a celebration of color to rival any festival.

Indian Paintbrush

The background is a flat, damp surface wash of Sap Green, into which foliage designs have been drawn freehand with a stylus. (Bruising technique)

The lower areas were textured with brown stippling. (.25)

Coreopsis buds

Coreopsis

Ruby-Throated Hummingbird

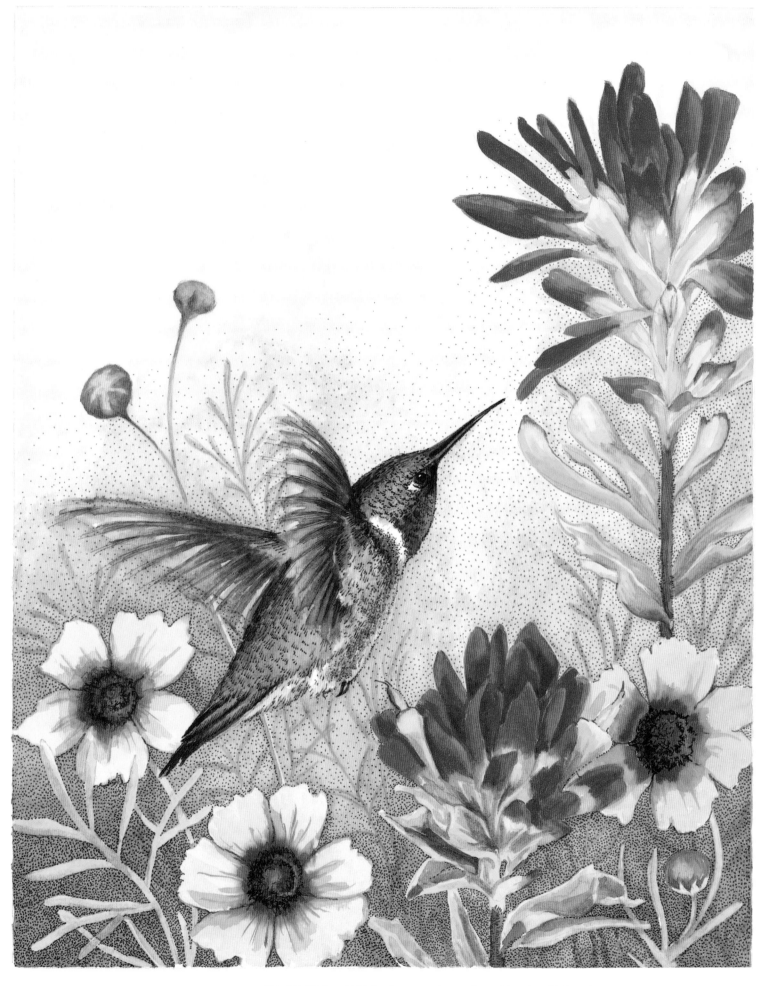

FLORAL FESTIVAL, 8″×10″ (20.3cm×25.4cm), watercolor washes with colored inkwork

Ground Squirrels & Mice

The ground squirrels and prairie dogs are similar in appearance, the latter tending to be larger. Both are burrowers. The small prairie deer mouse is at home among the grasses and flowers. Its plump, gray body would provide a nice "point of interest" to a floral study.

Pencil sketch

Preliminary layered washes

Black-tailed Prairie Dog →

Dry-brush detailing over washes of Yellow Ochre, Burnt Umber and Violet mixtures.

Fur depicted with Sepia ink in a .25 pen. (Criss-cross lines.)

Uinta Ground Squirrel, found in the sagebrush grass-lands of Montana to Utah.

Earthy mixtures of Yellow Ochre, Burnt Sienna and Sepia watercolors were used.

India ink pen sketch (.25)

Prairie Deer Mouse →

This small mouse is found throughout the Midwest. Its coat varies from gray to reddish-brown above and white below.

Cottontail

The Eastern Cottontail is the common "little brown rabbit" of the prairie region. It nests in thickets and brush piles, hopping out among the flowers and grasses to feed.

Cottontail quick sketch in scribbly Sepia lines. (.25)

① Pencil layout showing shadows and hair direction.

② A light wash of Burnt Sienna / Burnt Umber is brushed over a moist surface, leaving white areas unpainted. Let dry.

Illuminated eye crescent

③ A second wash of the same hue is dry brushed over the first wash in the shadow areas. Use a small flat or stroke brush and don't over blend the edges. The eye is blended around the illumination crescent with a damp round brush.

④ Use a (.25) pen and Sepia ink to add criss-cross hair strokes. Pay attention to hair direction and length. Lost white edges may be scratched back in with a razor.

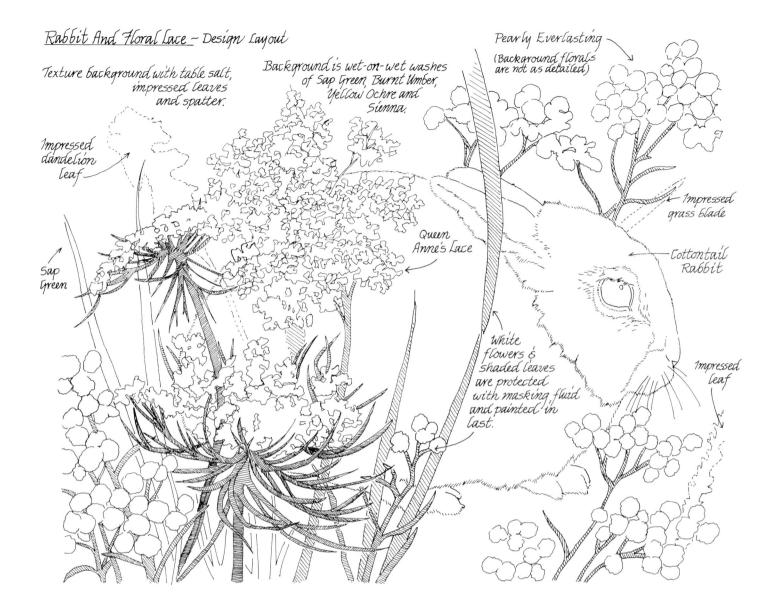

Rabbit And Floral Lace – Design Layout

Texture background with table salt, impressed leaves and spatter.

Background is wet-on-wet washes of Sap Green, Burnt Umber, Yellow Ochre and Sienna.

Pearly Everlasting
(Background florals are not as detailed)

Impressed dandelion leaf

Sap Green

Queen Anne's Lace

Impressed grass blade

Cottontail Rabbit

White flowers & shaded leaves are protected with masking fluid and painted in last.

Impressed leaf

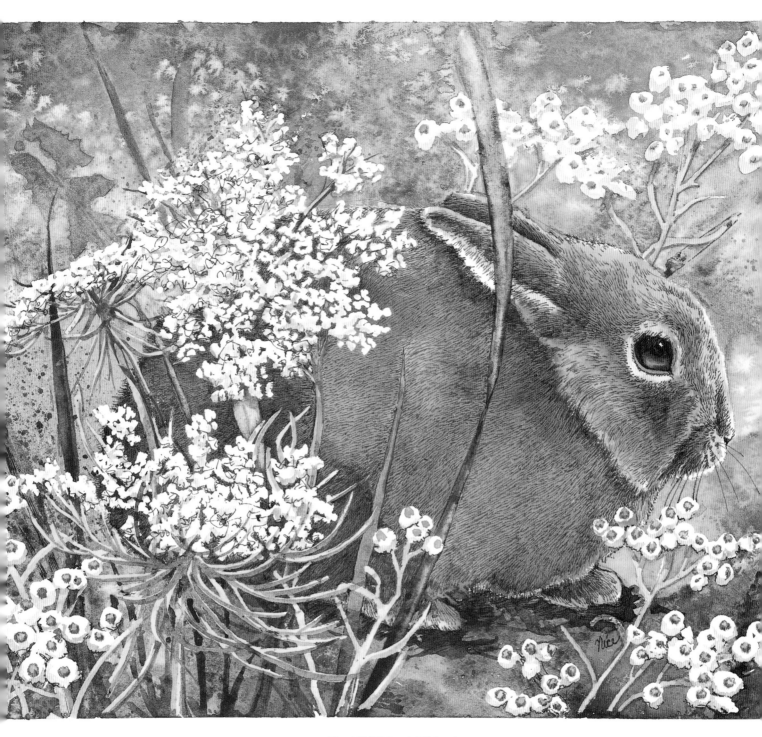

RABBIT AND FLORAL LACE, 8″×10″ (20.3cm×25.4cm),
watercolor and Sepia/Payne's Gray ink wash

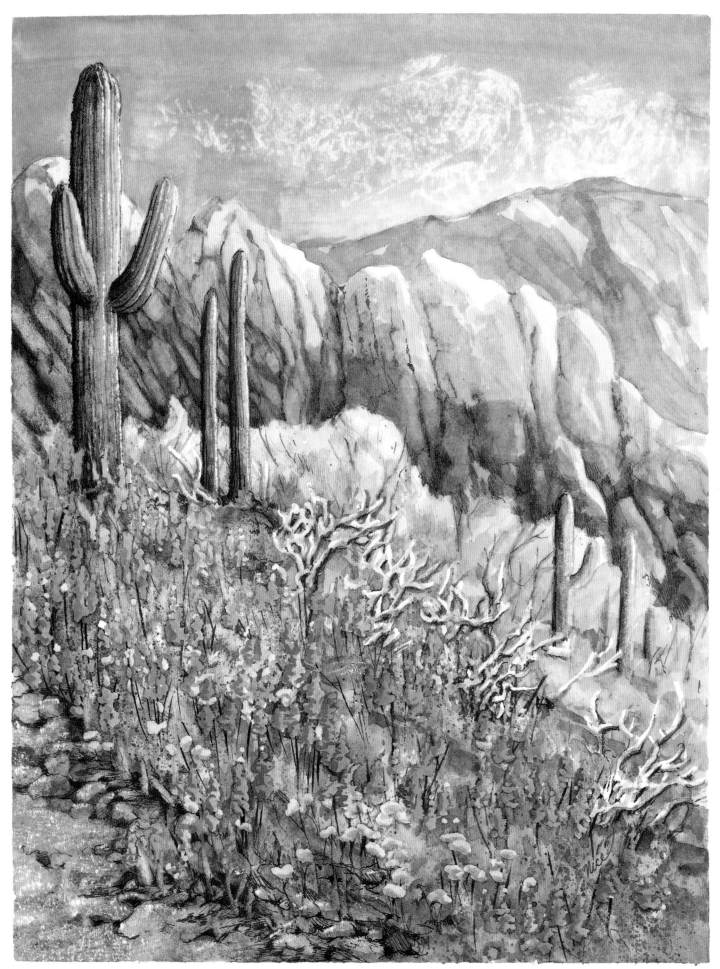

DESERT DRYLANDS

The word "desert" suggests a dry, harsh landscape of rocks, sand and thorn-covered vegetation. Yet the desert can be a place of high contrast and beauty for those who take the time to really look.

Rocks are polished to a sheen by desert sand and wind. The variety of types and colors are great. To fully appreciate a smooth desert pebble, you need to pick it up and feel the warmth of it in the palm of your hand. It may be speckled with quartz, marbled with minerals or simply tinted a delicate, pastel hue.

Raise your sights to the horizon. Study the grand rock formations, carved by the elements into statuesque shapes. The light plays over their surface, emphasizing the contours. The colors are subtle and earthy, the same mixtures that linger in the corners of a well-used watercolor palette.

Stand very still and lower your gaze. Let your eyes explore the ground, among the scattered stones and cast shadows, until you spot movement. There, staring at you from the crest of a rock, is a basking lizard. Only the rhythmic movement of its sides signals life—its camouflage is perfect! Catch him with your pen, pencil or camera, but keep your distance or he'll disappear.

The thorny bits of vegetation look shriveled and dead, but there is life within. Spring rains are all that are needed to awaken them to breathtaking splendor. The desert in bloom presents a rich contrast of austerity and delicate beauty, unsurpassed elsewhere. Orange, yellow and white poppies, blue lupines and magenta sand verbenas carpet the desert floor with color, while stark cacti put on crowns of vivid, translucent blossoms. If you can imagine the earthy, prickly cactus pads portrayed in pen and ink, and the blossoms coming to life in layered watercolor washes—the bold against the fragile—then you're ready to appreciate the artistic assets of the desert drylands.

SPRING DESERT LANDSCAPE, 10″ × 7½″ (25.4cm × 19.1cm), watercolor washes and Sepia inkwork

Pebbles

These small stones were picked up in the desert for study. I painted them using layered washes and varied texturing techniques. Marbled streaks were added by stroking ink lines over a dampened surface. Highlights were scratched in with a razor blade.

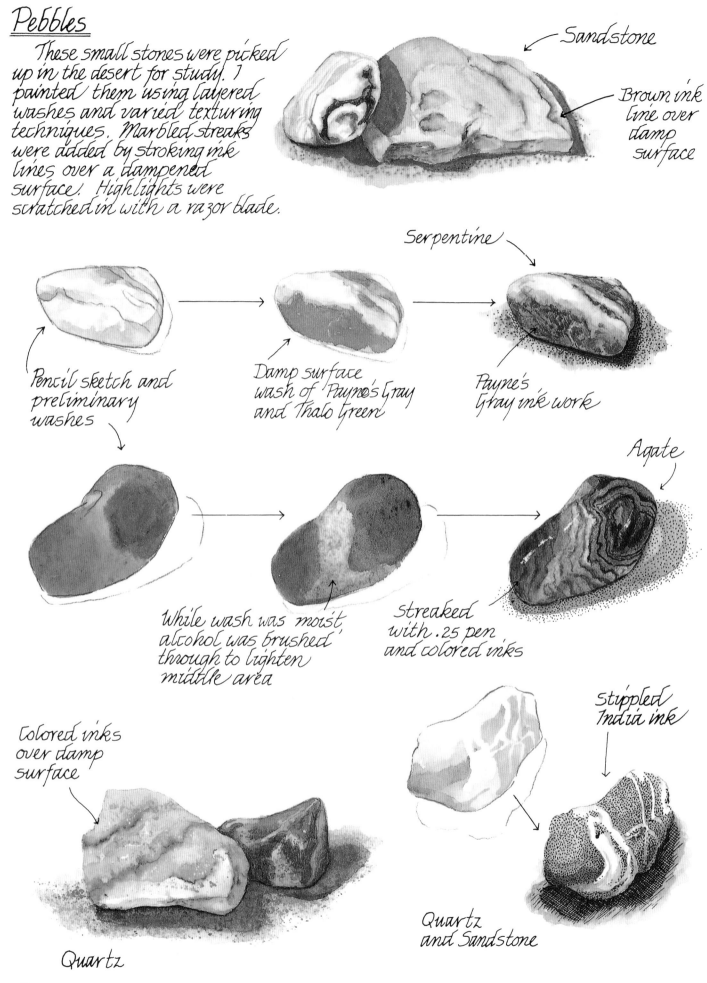

Sandstone

Brown ink line over damp surface

Serpentine

Pencil sketch and preliminary washes

Damp surface wash of Payne's Gray and Thalo Green

Payne's Gray ink work

Agate

While wash was moist, alcohol was brushed through to lighten middle area

Streaked with .25 pen and colored inks

Colored inks over damp surface

Stippled India ink

Quartz

Quartz and Sandstone

Lizards

Once you've mastered the depiction of desert rocks, you can add a bit of interest with a basking lizard. They are most likely to be found out in the open during the warm morning hours or late afternoon. Pen and ink crosshatching works well to suggest their scales.

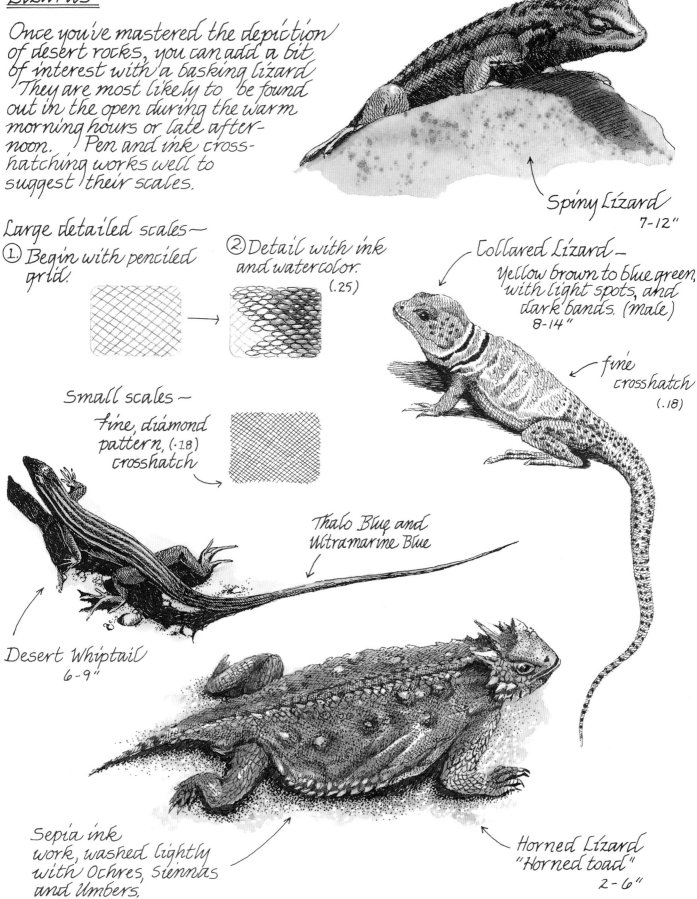

Spiny Lizard
7-12"

Large detailed scales —
① Begin with penciled grid.

② Detail with ink and watercolor.
(.25)

Collared Lizard —
yellow brown to blue green, with light spots, and dark bands. (male)
8-14"

fine crosshatch
(.18)

Small scales —
Fine, diamond pattern, (.18) crosshatch

Thalo Blue and Ultramarine Blue

Desert Whiptail
6-9"

Sepia ink work, washed lightly with Ochres, Siennas and Umbers.

Horned Lizard
"Horned toad"
2-6"

This desert floor painting began as a pen and India ink drawing to emphasize the gritty soil and lizard scales.

The sandstone pebbles were painted with layered, "dirty palette" watercolor washes. Spatter was used to texture the stones.

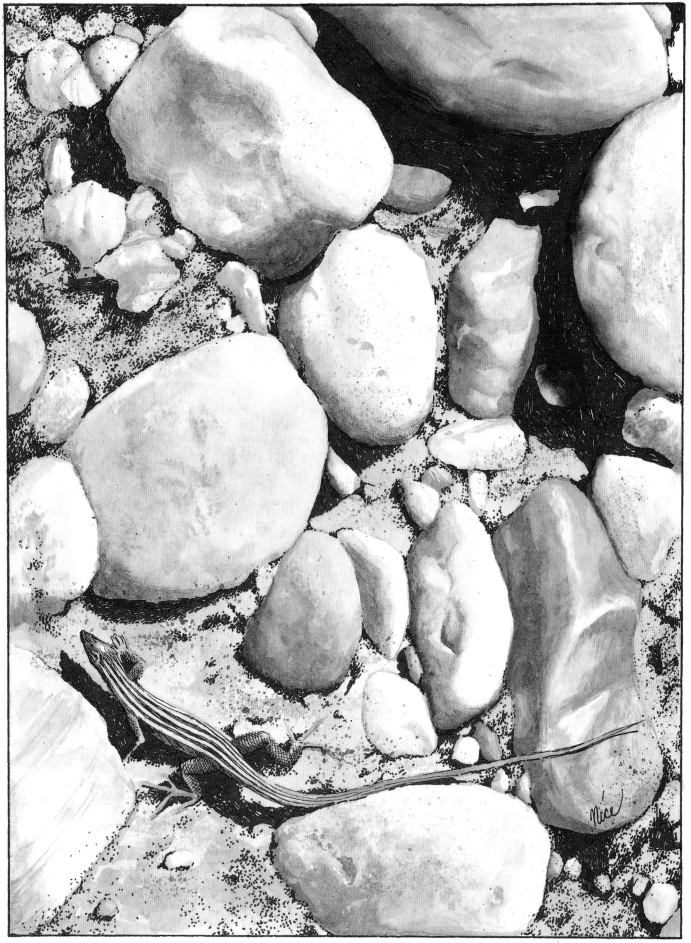

LIZARD ON ROCKY GROUND II, 6″×8″ (15.2cm×20.3cm), India ink drawing tinted with watercolor washes

Desert Birds

Birds which inhabit arid regions are often feathered in the earthy colors that surround them. Hues of ochre, umber, sienna and blue-gray provide a perfect camouflage for birds that hide among rocks and gray-green cacti.

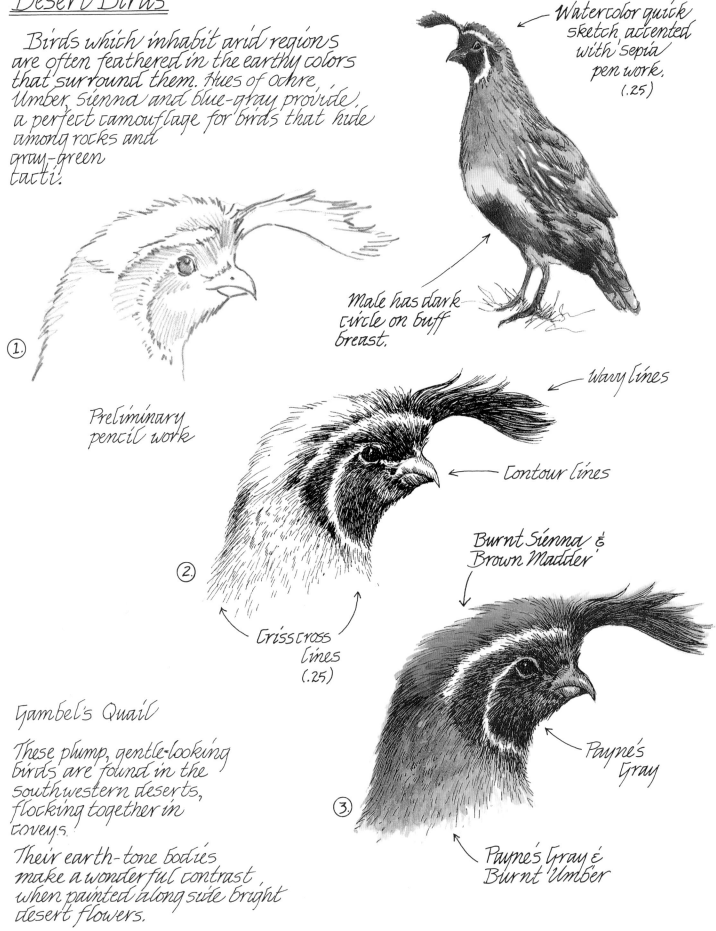

Watercolor quick sketch accented with sepia pen work. (.25)

Male has dark circle on buff breast.

① Preliminary pencil work

Wavy lines

Contour lines

② Crisscross lines (.25)

Burnt Sienna & Brown Madder

Payne's Gray

③ Payne's Gray & Burnt Umber

Gambel's Quail

These plump, gentle-looking birds are found in the southwestern deserts, flocking together in coveys.

Their earth-tone bodies make a wonderful contrast when painted alongside bright desert flowers.

82

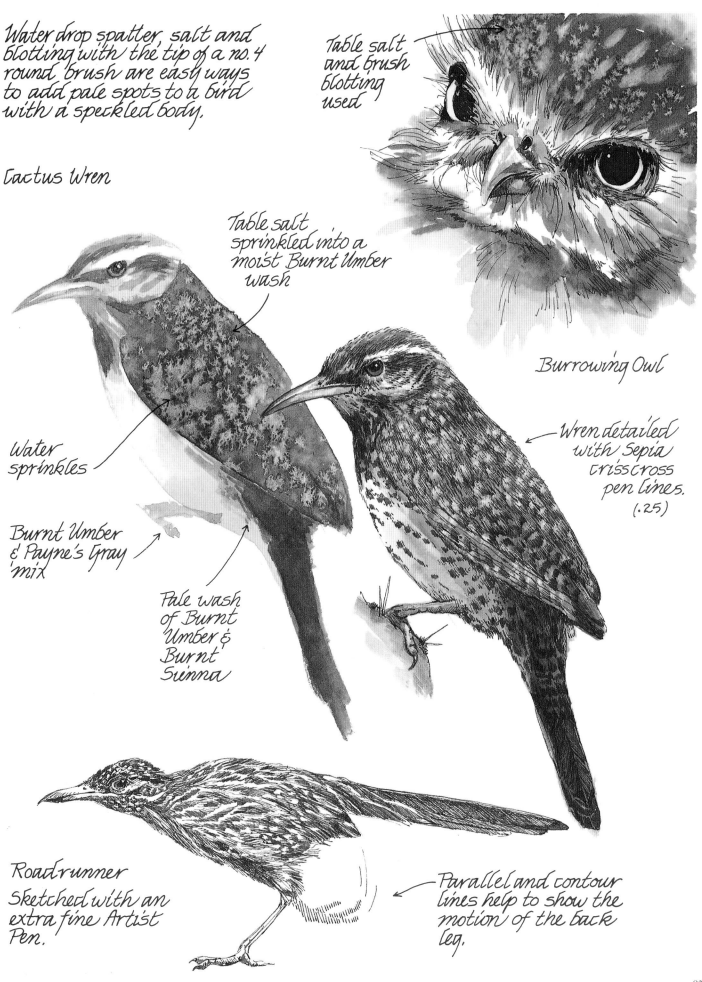

Water drop spatter, salt and blotting with the tip of a no. 4 round brush are easy ways to add pale spots to a bird with a speckled body.

Cactus Wren

Table salt and brush blotting used

Table salt sprinkled into a moist Burnt Umber wash

Burrowing Owl

Water sprinkles

Wren detailed with Sepia crisscross pen lines. (.25)

Burnt Umber & Payne's Gray mix

Pale wash of Burnt Umber & Burnt Sienna

Roadrunner
Sketched with an extra fine Artist Pen.

Parallel and contour lines help to show the motion of the back leg.

Desert Wildflowers

In the arid regions, flowers blossom and go to seed only after sufficient rain has fallen. The desert in full bloom is a rare sight, worthy of close study with camera, pen and brush.

— Base wash of Sap Green and orange mixture

— Shaded with a mixture of Sap Green / orange,

Thalo Green and Paynes Gray

California Poppy

① Light pencil line drawing and flat wash of Cadmium Yellow Medium.

② Petals are shaded with a wash of Cadmium Yellow Med. and Burnt Sienna.

③ Add Grumbacher Red to above mixture and deepen petal color near center.

④ Additional glazes of the orange mixture near the base of each petal will add color impact.

The center is defined with Burnt Sienna or Brown ink work.

Prickly Poppy

Textured with Paynes Gray, dry brush work

84

Thalo Red / Thio Violet mixture touched to wet surface with the tip of a no. 4 round brush.

Flower and leaves defined with dry brush work.

Brown ink work added. (.25)

Flower centers scratched with razor blade.

This Lupine drawing began with a light pencil sketch.

Flat washes of watercolor were added with a round detail brush.

Details and texture were added with a .25 Rapidograph and blue and green ink.

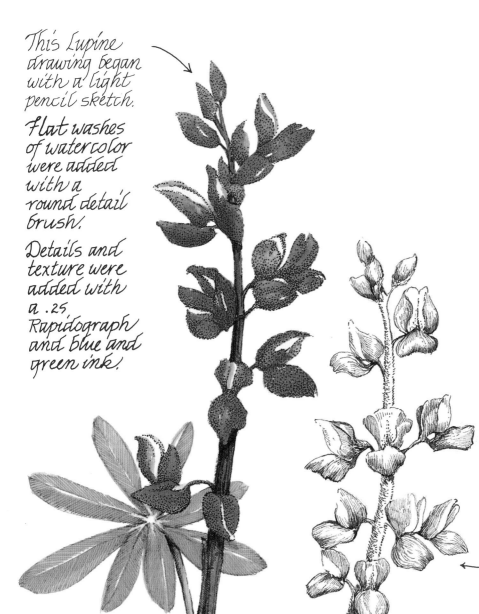

Sand Verbena (Above)

This trailing annual loves sandy soil. Its bright magenta flower clusters are wonderful additions to desert landscape paintings.

Lupine

These common perennial plants are found in many terrains and climates. In the desert, their purple-blue blossoms provide a perfect contrast to the orange poppies they grow beside.

Lupine study in brown ink. (.25)

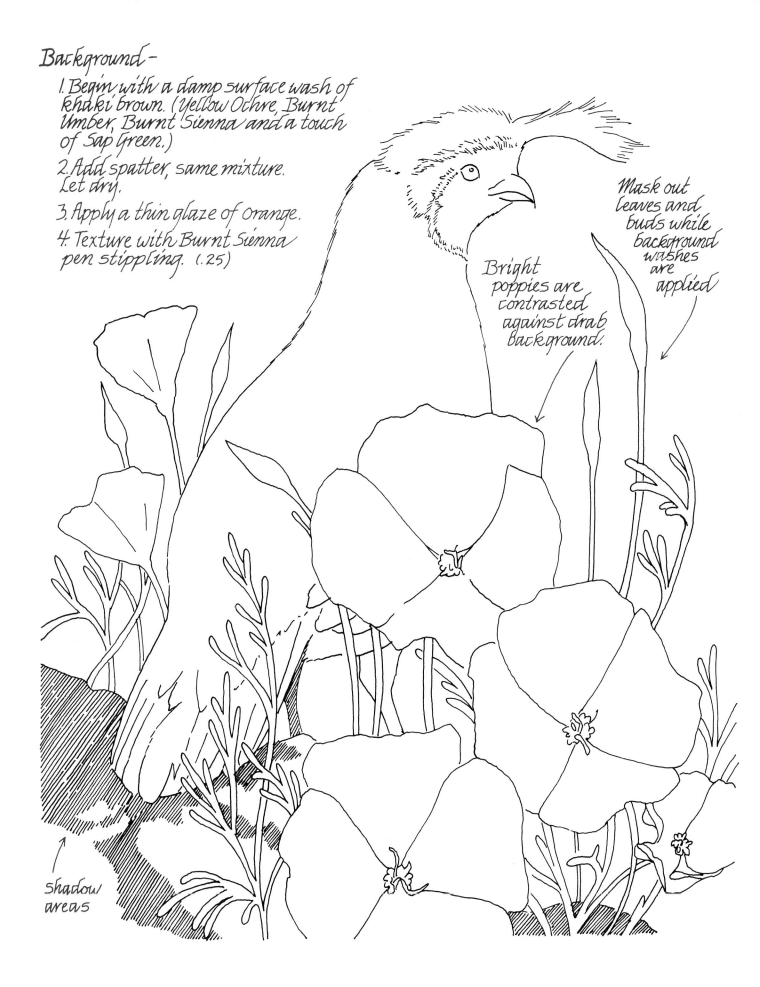

Background –

1. Begin with a damp surface wash of khaki brown. (Yellow Ochre, Burnt Umber, Burnt Sienna and a touch of Sap Green.)

2. Add spatter, same mixture. Let dry.

3. Apply a thin glaze of orange.

4. Texture with Burnt Sienna pen stippling. (.25)

Mask out leaves and buds while background washes are applied

Bright poppies are contrasted against drab background.

Shadow areas

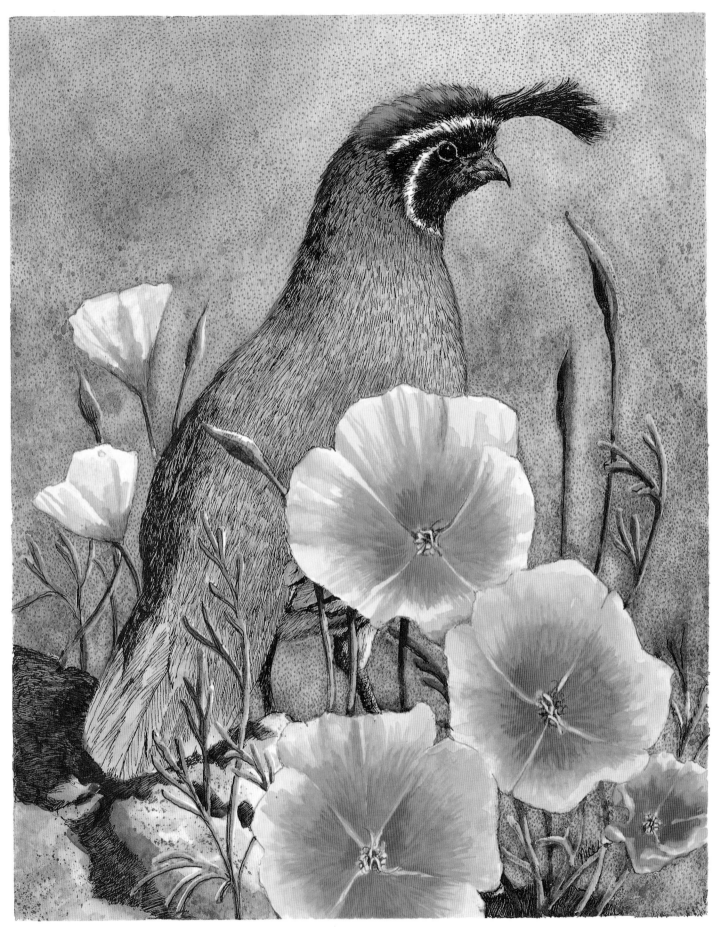

QUAIL AND POPPIES, 8″×10″ (20.3cm×25.4cm), mixed media combining India ink, layered watercolor washes and brown ink stippling

Begin the cactus flower with a damp surface wash of Cadmium Yellow Lemon.

Cacti

The first time I tried combining the textures of pen & ink and watercolor was during the sketching of a cactus in bloom. The contrast of bold, ink-sketched thorns against delicate watercolor blossoms was so "natural" that it remains one of my favorite mixed media subjects.

Sketching hint: The thorns on most cacti are arranged in a set pattern, rather than a random scattering.

Use a .25 Rapidograph to texture the cactus pad. (Contour and Crosshatch lines)

Add a touch of Orange and Thalo Violet to Lemon Yellow for shadows.

Keep blossom light and translucent!

Cactus pads are tinted with Thalo Green, Thalo Violet and dirty palette mixtures.

Purple Prickly Pear Cactus

(fruit is purple)

← Cactus body and thorns rendered
in India Ink, then tinted with
watercolor washes.

← Contour lines in Burnt Sienna Ink
help define the petals.

Background was textured
with table salt and rock
salt to suggest distant
thorn clumps. The foreground
thorns and flower stamens were
"masked" during the painting
process. Thorns are outlined in Sepia!

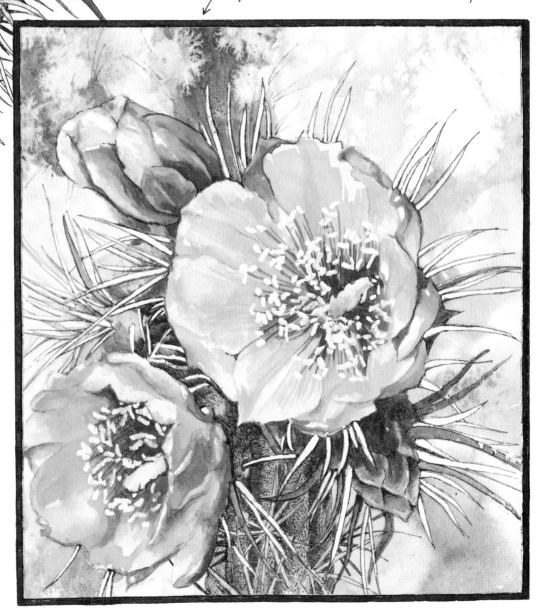

Yellow Cholla

The flowers on
this cactus
vary from deep
yellow to
reddish violet.

This color
combination
makes the
blossoms seem
to vibrate with
intensity.

Sketching the cactus body—

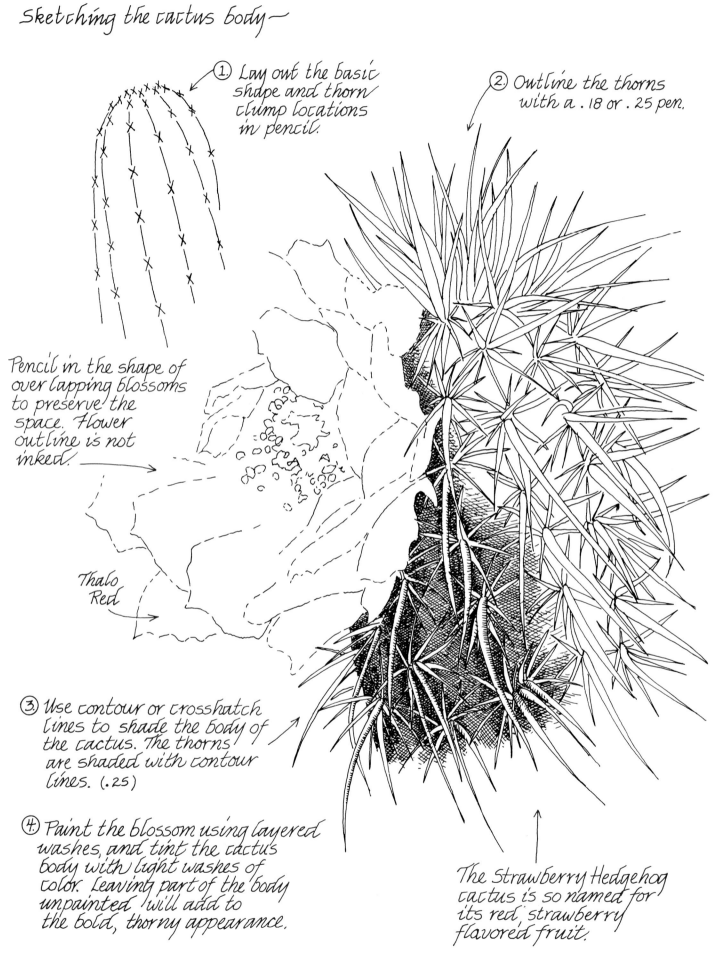

① Lay out the basic shape and thorn clump locations in pencil.

② Outline the thorns with a .18 or .25 pen.

Pencil in the shape of over lapping blossoms to preserve the space. Flower outline is not inked.

Thalo Red

③ Use contour or crosshatch lines to shade the body of the cactus. The thorns are shaded with contour lines. (.25)

④ Paint the blossom using layered washes, and tint the cactus body with light washes of color. Leaving part of the body unpainted will add to the bold, thorny appearance.

The Strawberry Hedgehog cactus is so named for its red, strawberry flavored fruit.

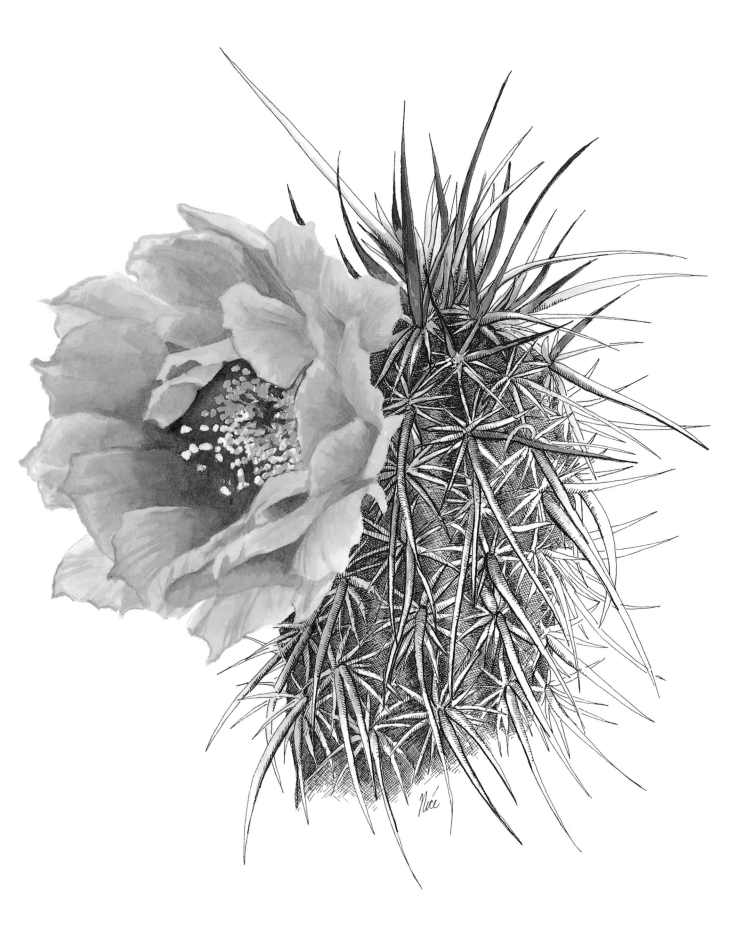

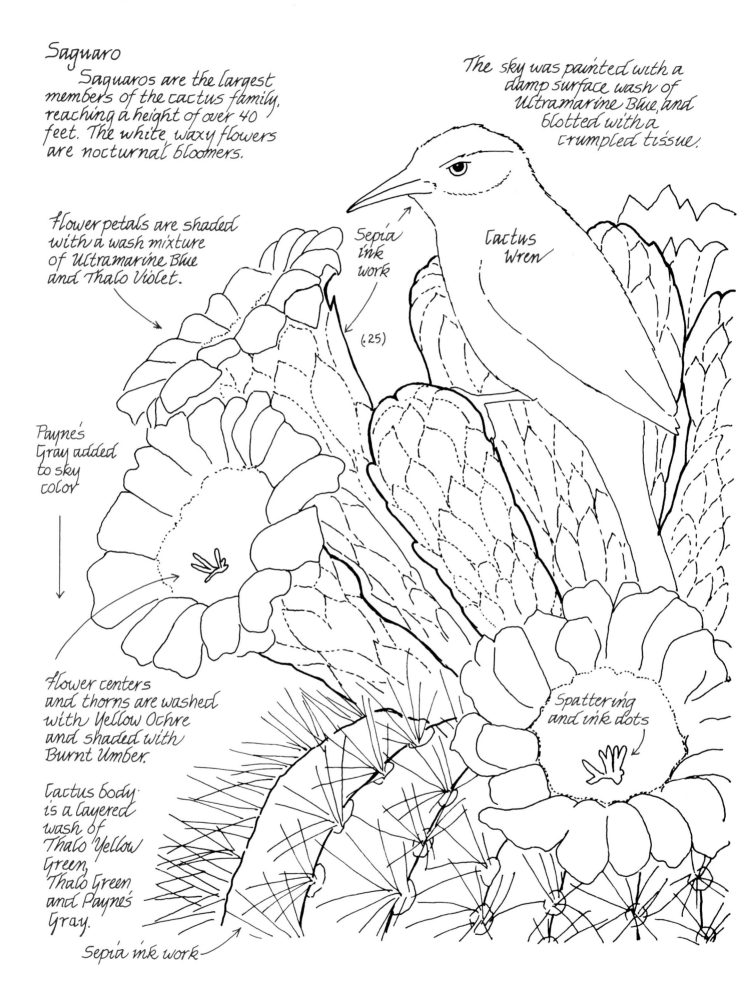

Saguaro

Saguaros are the largest members of the cactus family, reaching a height of over 40 feet. The white waxy flowers are nocturnal bloomers.

The sky was painted with a damp surface wash of Ultramarine Blue, and blotted with a crumpled tissue.

Flower petals are shaded with a wash mixture of Ultramarine Blue and Thalo Violet.

Sepia ink work

(.25)

Cactus Wren

Payne's Gray added to sky color

Flower centers and thorns are washed with Yellow Ochre and shaded with Burnt Umber.

Cactus body is a layered wash of Thalo Yellow Green, Thalo Green and Payne's Gray.

Spattering and ink dots

Sepia ink work

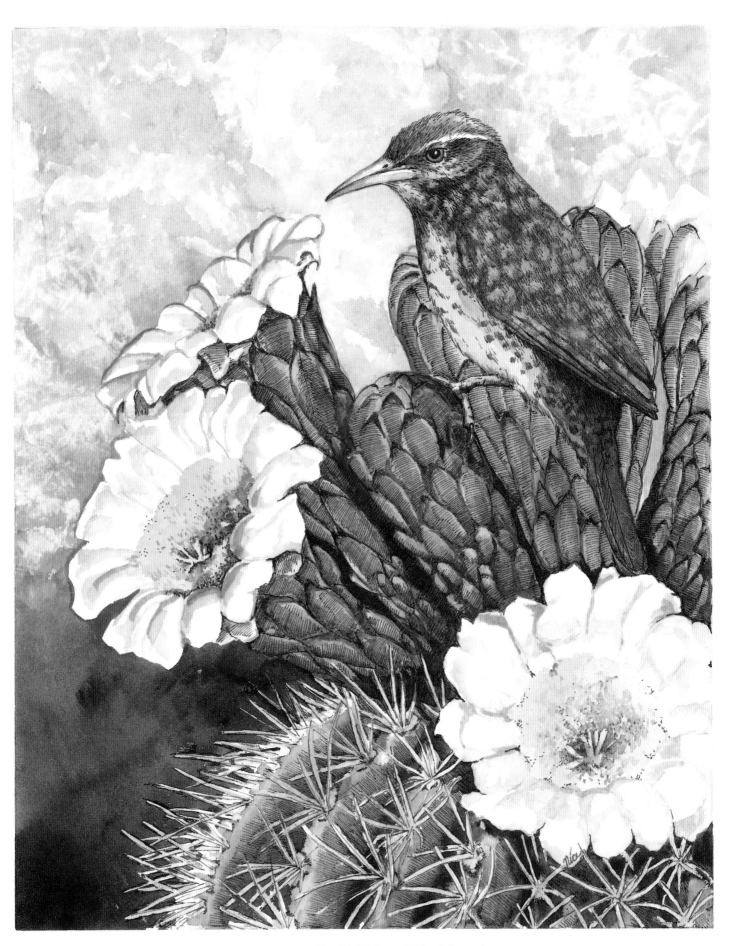

SAGUARO, 8″×10″ (20.3cm×25.4cm), layered
watercolor washes, textured with Sepia ink

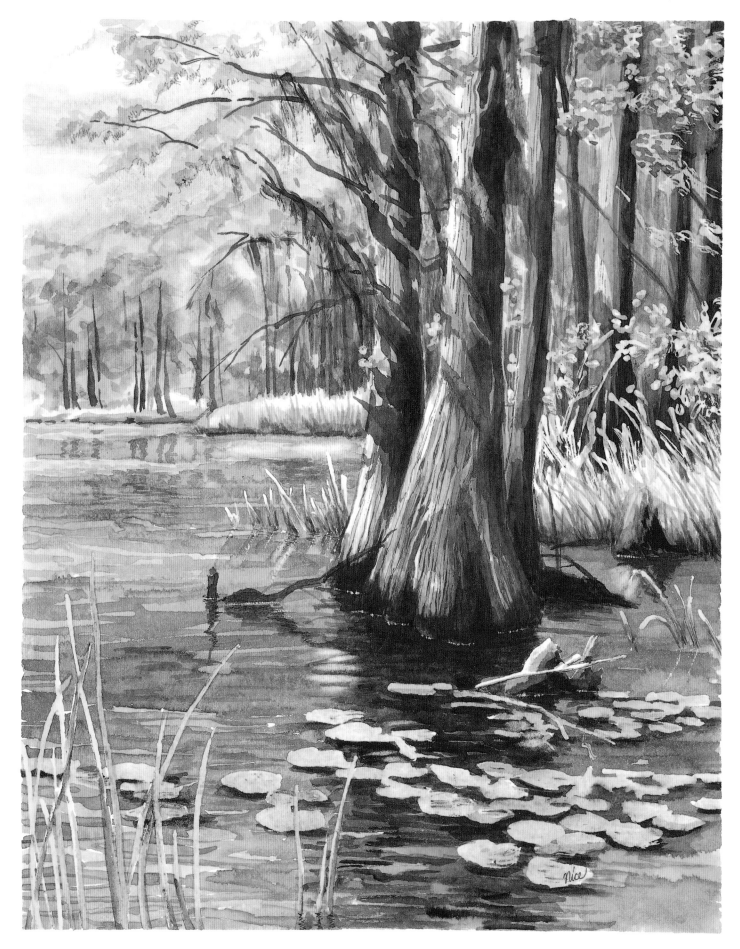

CYPRESS WETLAND, 8″ × 10″ (20.3cm × 25.4cm),
watercolor detailed with Payne's Gray penwork

PONDS, SWAMPS AND MARSHES

Welcome to the wetlands. Here water is the main feature. If the wetland looks like a prairie with varied grasses, sedges, rushes and cattails merged with pools of water, it's considered a marsh. When bodies of still or slowly moving water intermix with forest lands, it's a swamp. In order to support themselves in the soft mud, swamp trees like the Bald Cypress and the Tupelo have buttressed trunks and vast root systems. Springing from the roots are gnarled knees that rise above the water like wooden stalagmites.

As seen in the painting on the opposite page, swamplands and marshes can be mingled. Towering Bald Cypresses yield to dense mats of rushes, which in turn give way to the deeper waters of a pond and floating rafts of lily pads.

As an artist and amateur naturalist, I am fascinated by all types of wetlands with their vast array of unique plants and animals. In the brightly lit marshes, the earthy greens and browns of the graceful rushes set off the splendor of the waterfowls to perfection. Water reflections are vivid and as varied as a kaleidoscope.

The filtered light of the swamp adds the drama of extreme highlight and shadow to a habitat already rich in intrigue. Here is a treasure chest of value contrasts, unusual shapes and diverse textures. In your mind's eye, consider sediment-stained waters lapping lazily against a rough and twisted cypress knee. Present are the rich greens of water plants, mingled with dollops of sunlight.

A dragonfly hovers above the scene, adding a dash of iridescent color. And there at the base of the cypress knee, a turtle hides in subtle camouflage. If this vision excites your artist's imagination, then it's time to put on your boots and venture into the wetlands. In this chapter, I'll introduce you to some of my favorite swampy flora and fauna and the techniques that will make sketching them easier.

A word of caution, from personal experience—the southern swamplands are not a good place for the novice to explore alone. One never knows what might swim, crawl or slither out of those deep and mysterious shadows!

All birds seem to share two basic shapes-
The head is oval or round, depending on the view, and the body is egg shaped, the narrow end of the egg pointing toward the tail.

oval

egg shaped

Snowy Egret (.18)

A quick water-color sketch of a young Great Blue Heron.

The colors available on a used, "dirty," watercolor palette are great for this type of sketch.

Marshland Waterfowl

The easiest wild life to spot in the wetlands are the birds. The web-footed swimmers and stilt-legged stalkers are common, but seldom pose for long. Quick sketches and cameras can record them, for more detailed studio paintings.

Cypress knees

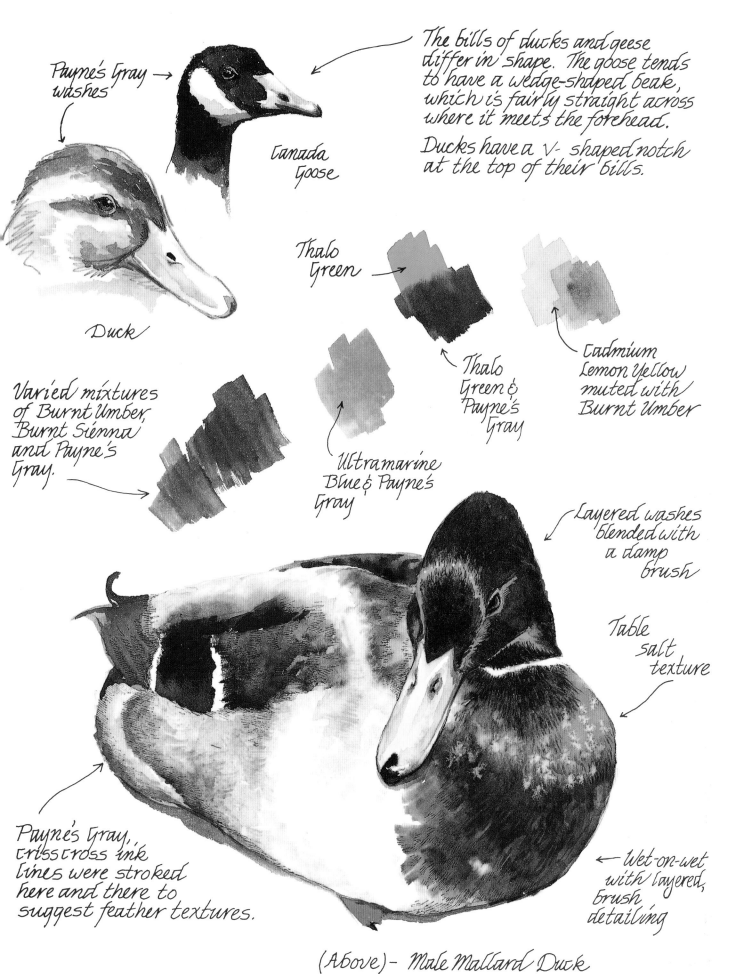

Payne's Gray washes

Canada Goose

The bills of ducks and geese differ in shape. The goose tends to have a wedge-shaped beak, which is fairly straight across where it meets the forehead.

Ducks have a V-shaped notch at the top of their bills.

Duck

Thalo Green

Thalo Green & Payne's Gray

Cadmium Lemon Yellow muted with Burnt Umber

Varied mixtures of Burnt Umber, Burnt Sienna and Payne's Gray.

Ultramarine Blue & Payne's Gray

Layered washes blended with a damp brush

Table salt texture

Payne's Gray, criss cross ink lines were stroked here and there to suggest feather textures.

Wet-on-wet with layered, brush detailing

(Above) - Male Mallard Duck

The female Mallard is mottled brown in color, blending well into the murky pond water surrounding her.

When painting such subjects, contrast of texture becomes the key to definition— soft, fluffy feathers against smooth, glossy ripples.

crisscross ink lines

India ink tinted with washes

Burnt Umber, wavy pen work.

Layered washes →

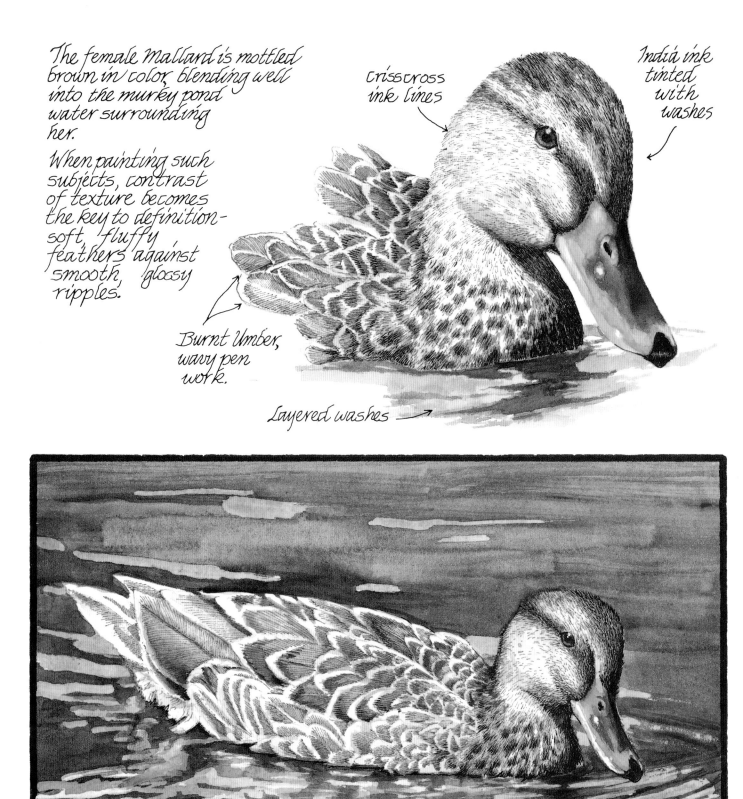

Bullfrog

① Preliminary pencil sketch

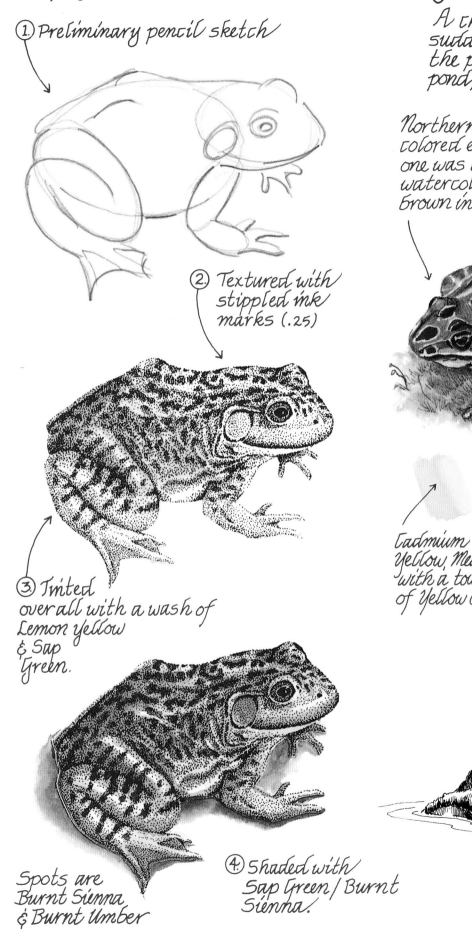

② Textured with stippled ink marks (.25)

③ Tinted over all with a wash of Lemon Yellow & Sap Green.

Spots are Burnt Sienna & Burnt Umber

④ Shaded with Sap Green / Burnt Sienna.

Frogs

A chorus of croaks and a sudden splash announces the presence of frogs in the pond, long before they are seen.

Northern Leopard frogs can be colored either green or brown. This one was washed with layers of watercolor, then detailed with brown ink.

Cadmium Yellow, Medium with a touch of Yellow Ochre

Yellow Ochre & Burnt Umber

Burnt Umber

Front view, pen and ink study.

Water Lilies

These floating aquatic flowers are protected from splashing pond ripples by the round, flat lily pads that surround them.

The specialized leaves are smooth, tough and rubbery, and can be depicted quite nicely with layered watercolor washes.

① Begin with a pencil sketch to define the lilies, leaves and stems.

Stipple the pond background area with India ink and a .25 - .35 nib.

Cadmium Yellow, Med.

Ultra-Marine & Payne's Gray

② Lay in the preliminary, damp surface washes using a 1/4" stroke brush.

Burnt Sienna & Thio Violet muted with a touch of Sap Green

Sap Green, muted with a little Burnt Sienna

③ Add additional layers of watercolor to shade and define the painting. Let each thin layer dry before adding another.

Blend and soften edges with a clean, damp stroke or round brush.

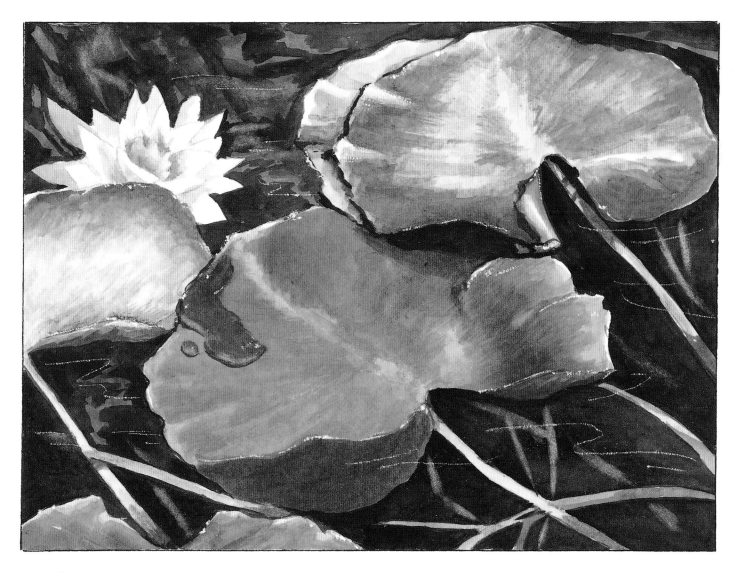

Lily pad mixture—
Burnt Sienna & Thio Violet, muted slightly with Sap Green.

Use a pastel version of this mix to overlay the flower petals.

Darken the water shadows with a mixture of Payne's Gray & Burnt Umber.

Blotted with a damp stroke brush.

Highlights scratched in with a razor blade.

Sap Green & Burnt Sienna

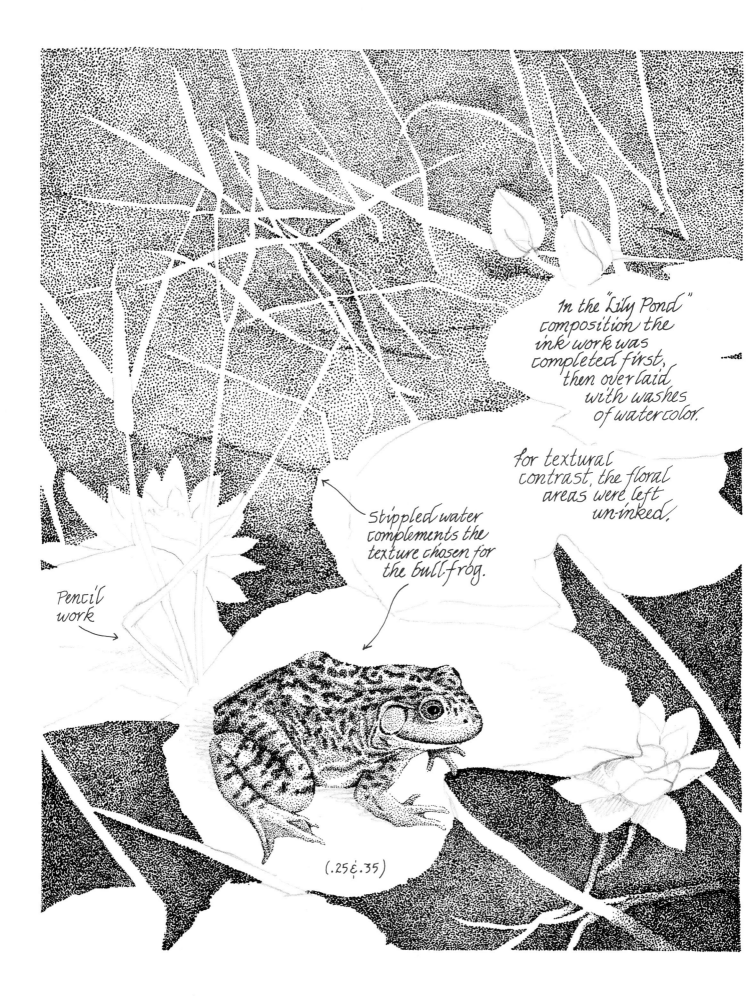

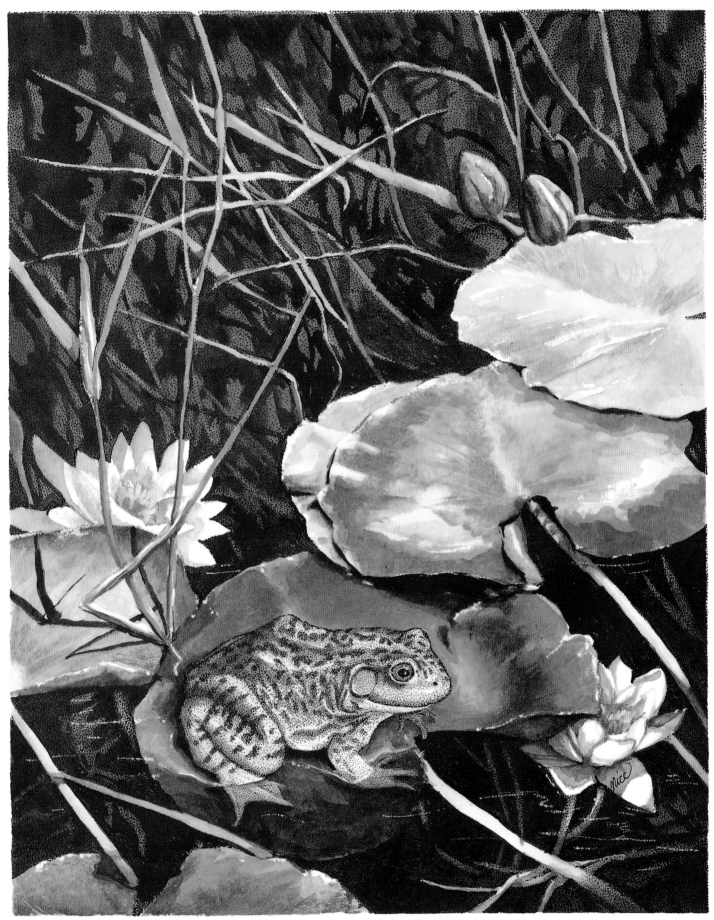

LILY POND, 8″×10″ (20.3cm×25.4cm), India ink stippled drawing, overlaid with layered watercolor washes

Dragonflies And Damselflies

These aquatic insects are a common sight in swamp lands, flitting both forward and backward above the water.

Begin with a light pencil sketch.

Wings detailed with a no. 4 round brush.

Thalo Blue plus Ultramarine Blue

Shade body with .25 pen and India ink.

Use light washes of background color to tint wings.

Damselflies fold their wings backward while at rest.

Thio Violet & Ultramarine Blue

Wing veins were bruised into the damp surface wash with a stylus.

Stippled Dragonfly
(.25)

Dragonflies spread their wings while at rest.

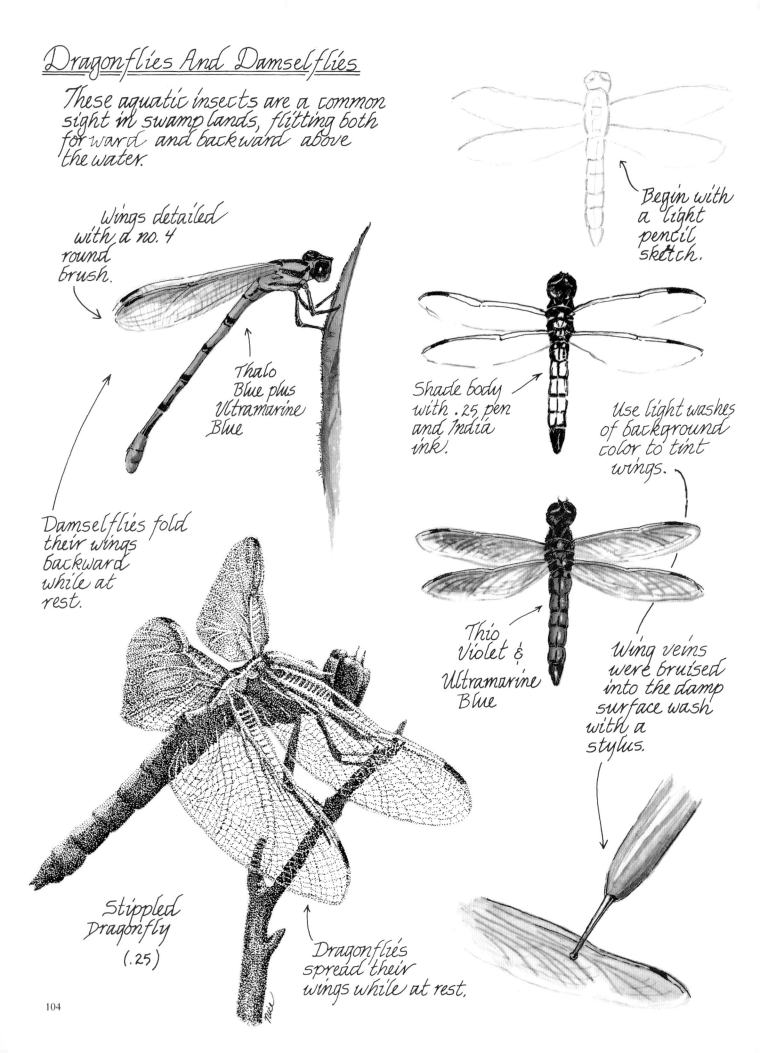

Turtles

Often found basking lazily in or near the water, turtles make excellent subjects to sketch in the wild.

Old shell was faded and weathered, so muted color mixtures were used.

Palette: Payne's Gray
Burnt Sienna
Yellow Ochre
Cadmium Yellow, Med.

Yellow design was masked out.

Box Turtle study, painted with layered watercolor washes.

(The legs and neck were retracted in readiness to hide if I moved closer).

Underside of Box Turtle

Dark designs were applied wet-on-wet.

Sap Green & Payne's Gray

Cadmium Yellow Med. & Thalo Red mix

Painted Pond Turtle sketch is contour line pen work tinted with watercolor.

(.25)

Dark Swamp Background

1.

1A. Mask out foreground images until background is finished.

1B Lay down a varied wash of Sap Green and Burnt Sienna. Let dry.

2.

2A. Brush on a second paint layer of Sap Green / Payne's Gray.

2B. Impress wrinkled plastic wrap into the wet wash and secure until dry... then remove.

Caution – Paint tends to creep along plastic wrap folds into non-painted areas.

3.

3A. Further darken background with a Sap Green wash. Let dry.

3B. Use a moist ¼" stroke brush to rub reed shapes into the layered background. Blot with a tissue to reveal original paint wash.

4.

Further texture and darken the background with scribbly pen strokes. (India ink)

Remove liquid frisket with masking tape and paint foreground images.

Pickerelweed

This arrowhead-shaped plant grows in shallow water, at the edges of East Coast ponds and slow streams.

Leaves are thick and glossy. White highlight areas suggest the surface sheen.

① Light watercolor washes, applied with a 1/4" stroke brush, to a damp surface.

② Shadow areas are deepened with additional paint layers.

Let each layer dry before adding the next.

Sketched beside a Florida pond.

③ Detail the leaves and flower stalks lightly with Payne's Gray ink work.

Individual blossoms have 3 sepals and 3 petals which look alike.

Sap Green plus Cadmium Yellow med.

Sap Green

Sap Green plus Thalo Green

Sap Green plus Payne's Gray

Thio Violet plus Ultra-Marine Blue

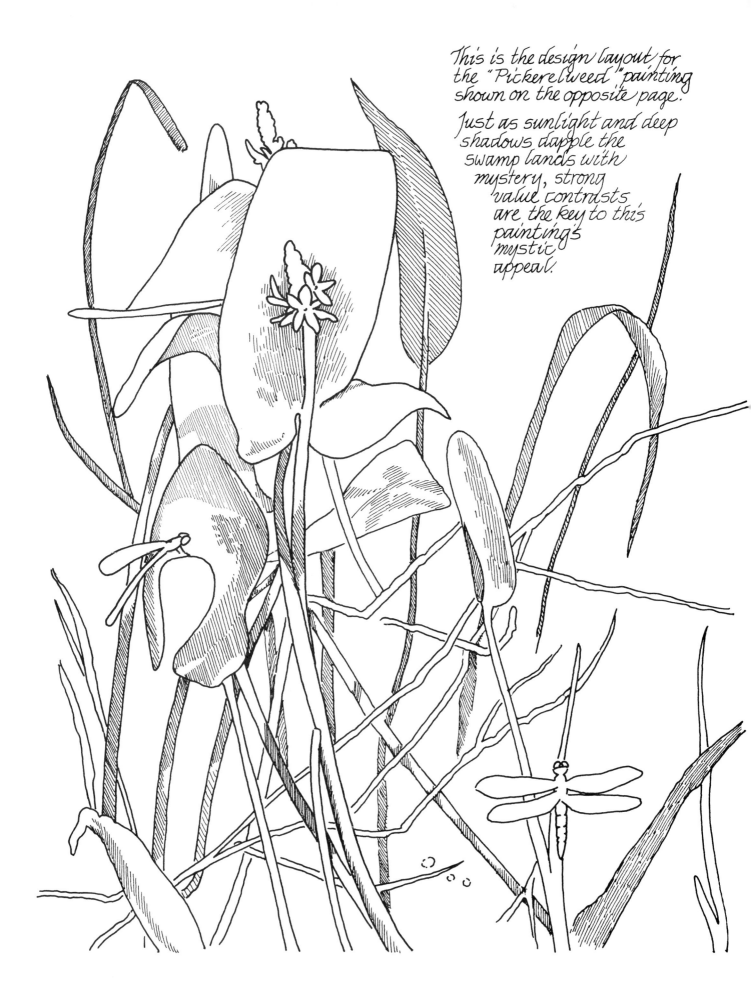

This is the design layout for the "Pickerelweed" painting shown on the opposite page.

Just as sunlight and deep shadows dapple the swamp lands with mystery, strong value contrasts are the key to this paintings mystic appeal.

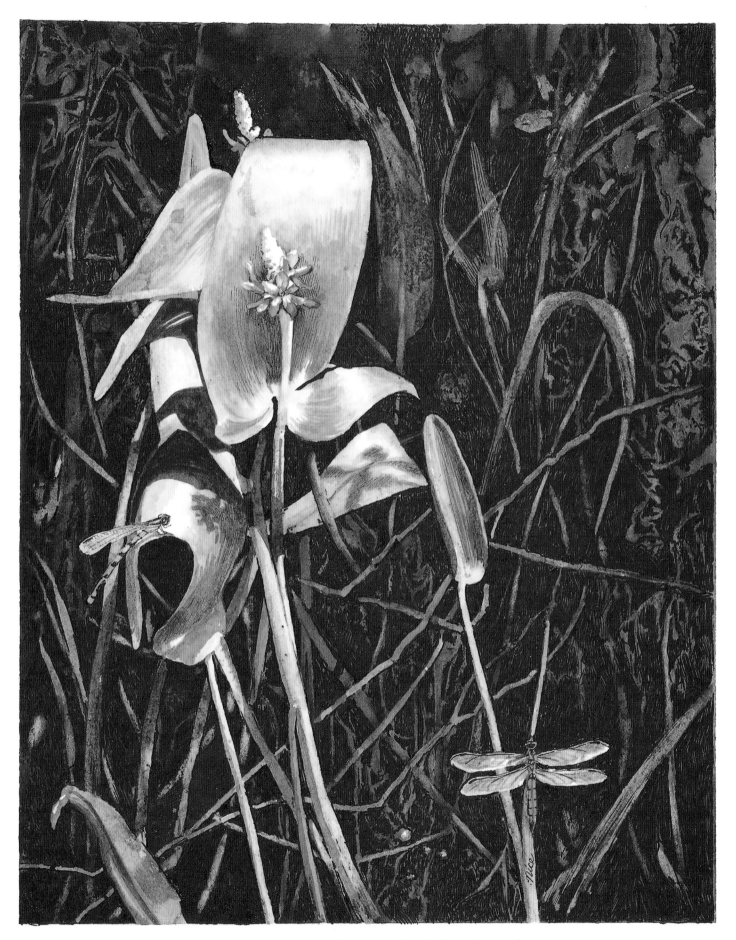

PICKERELWEED, 8″×10″ (20.3cm×25.4cm), layered watercolor
washes textured with impressed plastic wrap, blotting and penwork

109

Cattails

These useful fresh water reeds grow throughout North America! The starchy roots and young shoots are both edible and delicious. Craftsmen weave cattail leaves into rush seats and artists find the sausage like heads, cottony seed puffs and graceful fronds irresistible to pen and paint.

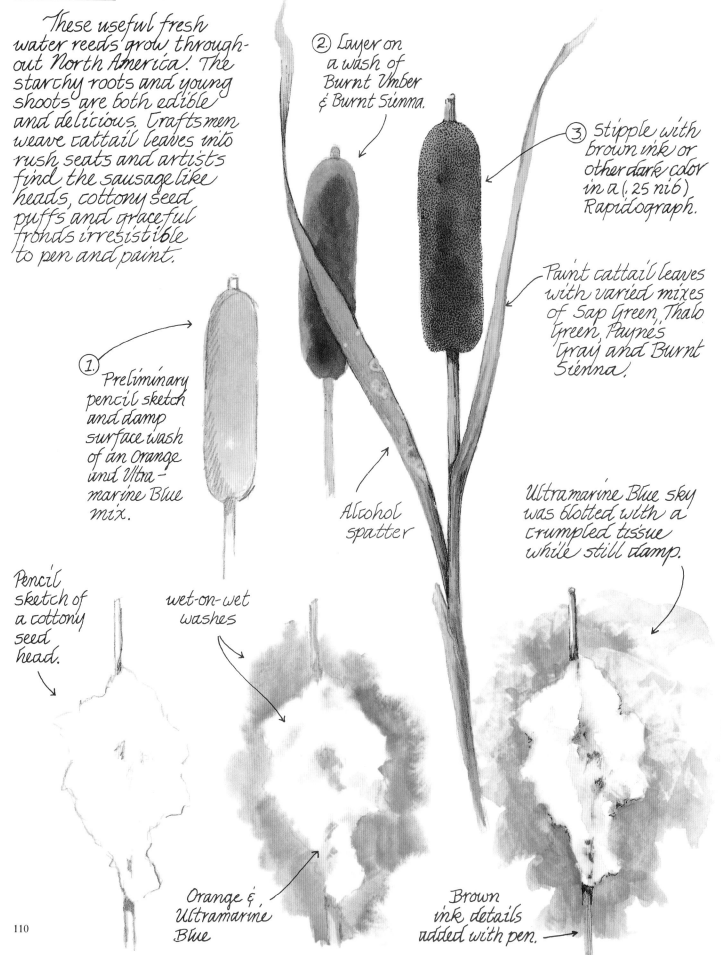

② Layer on a wash of Burnt Umber & Burnt Sienna.

③ Stipple with brown ink or other dark color in a (.25 nib) Rapidograph.

Paint cattail leaves with varied mixes of Sap Green, Thalo Green, Payne's Gray and Burnt Sienna.

① Preliminary pencil sketch and damp surface wash of an Orange and Ultramarine Blue mix.

Alcohol spatter

Ultramarine Blue sky was blotted with a crumpled tissue while still damp.

Pencil sketch of a cottony seed head.

wet-on-wet washes

Orange & Ultramarine Blue

Brown ink details added with pen.

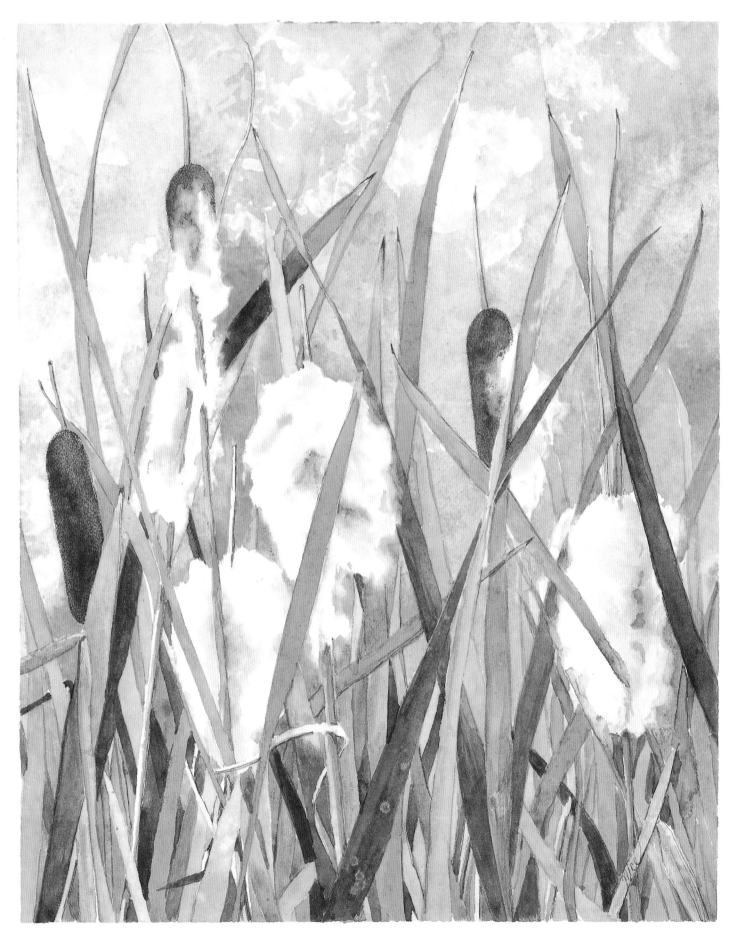

CATTAIL FLAGS, 8″×10″ (20.3cm×25.4cm), watercolor washes
textured with blotting and alcohol spatter, enhanced with brown stippled penwork

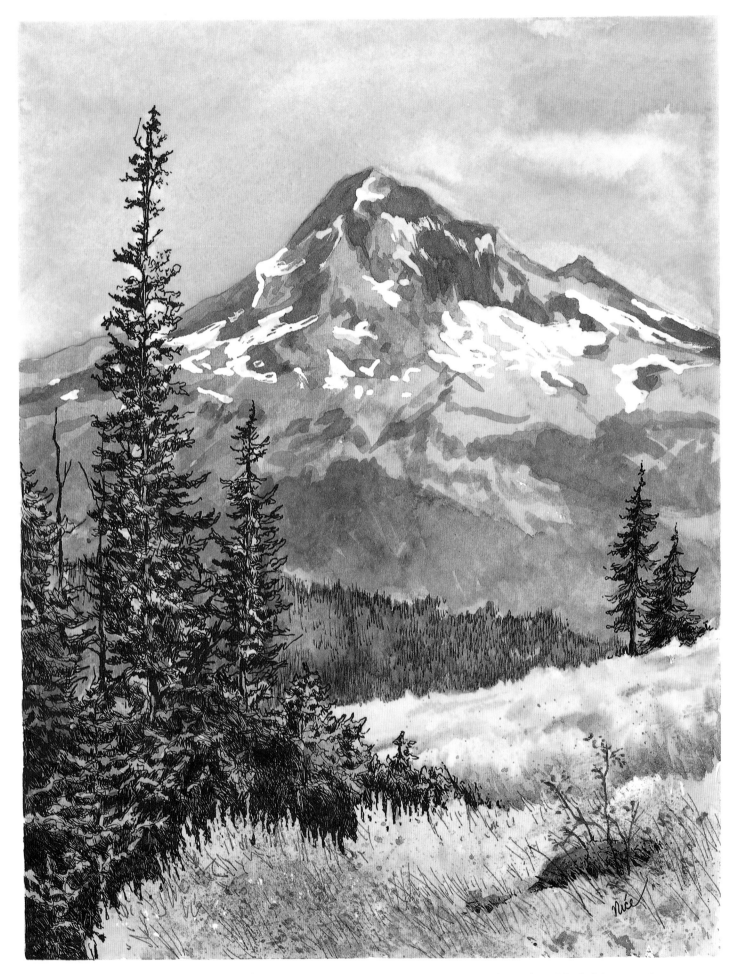

MT. HOOD IN SUMMER, 8″×10″ (20.3cm×25.4cm), watercolor washes textured with sepia and India ink penwork

MOUNTAINS, CRAGS AND CREVICES

High and rocky are the two words that best describe the terrain featured in this chapter. Rocks are the nature of the mountains. The higher you go, the more apparent they become. Near the top, stony cliff faces peer out from winter cloaks of snowy white. Like ancient patriarchs, the faces are seamed and weathered with age. Their children are the rock boulders that break away and romp rebelliously down the slopes, coming to rest in great congregations.

Above the rocks, eagles soar. Beneath the rocks, the creatures build their dens. Upon the rocks, alpine flora clings to life. In the mountain highlands, life is spartan and fast-paced. Plants don't waste time growing tall. Large, bright blossoms are their glory and reproduction their mission, all the while racing the time clock in a precarious climate. One can only stand in awe at the tenacity of life that flourishes amid such hardship.

As the seasons cycle, melting snow sends cascades of water dancing over the rocks in a rhythm as old as the mountains themselves. Light plays across the falling water and sparkles like the crystals of a chandelier. Is it the sound or sight of the tumbling water that catches the stride of the passerby and causes him to pause and appreciate? Be you naturalist, poet or painter, the mountains are a compellng inspiration. Linger awhile, and in the following pages we'll explore a few of the mountains, crags and crevices. Then perhaps you'll plan a trip of your own to pen and paint the delights of the alpine scene.

Stonecrop (Sedum Family)

This small succulent sprouts from crevices in cliffs, talus slopes and rocky outcrops, forming short, dense mats of blue-green rosettes.

Varied mixtures of Sap Green, Thalo Green and Thalo Blue

Yellow Ochre

② Define shapes with additional layered washes.

③ Add dark wash background to contrast pastel flowers.

Note: Masking the Stonecrop will allow the background to be applied first. The choice is up to the whim of the artist.

Gamboge

① Begin with flat water-color washes.

Thalo Red muted with green

Lift out highlight areas from damp wash with a detail brush

India Ink stippling adds contrasting texture to the gray rock background.

114

Talus Rock And Lichen

Talus rocks are the old fragmented stones that break off and tumble down the mountain to form great sloping piles. These rocks become textured with a variety of lichen.

① Begin with a varied damp surface wash of Payne's Gray, Burnt Umber and violet. Add a few "dirty palette" grays and browns for variety.

A wash of blue-green is added here as a reflection of local color.

② While the wash is still damp, use alcohol to stroke in some light toned lichen spots.

③ Further texture the rocks with dark brown-grays and earthy greens applied with a sea sponge and spattering.

Alcohol, spatter, sponging and colored ink pen work were used to texture the lichen.

④ A scribbling of Payne's Gray pen work gives the lichen additional definition.

Like a tapestry of abstract design, lichens cling to the high mountain rocks where nothing else will grow.

Orange Star Lichen – A crustose (crust-like) lichen.

Foliose or leaf-like lichen with fruiting cups.

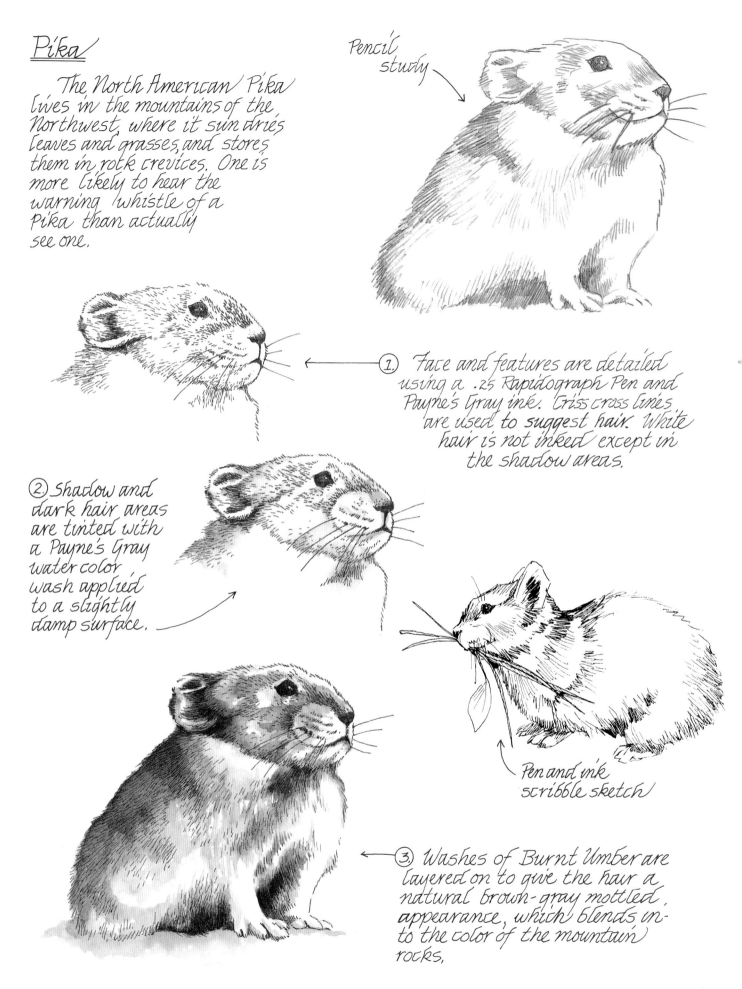

Pika

The North American Pika lives in the mountains of the Northwest, where it sun dries leaves and grasses, and stores them in rock crevices. One is more likely to hear the warning whistle of a Pika than actually see one.

Pencil study

① Face and features are detailed using a .25 Rapidograph Pen and Payne's Gray ink. Criss cross lines are used to **suggest** hair. White hair is not inked except in the shadow areas.

② Shadow and dark hair areas are tinted with a Payne's Gray water color wash applied to a slightly damp surface.

Pen and ink scribble sketch

③ Washes of Burnt Umber are layered on to give the hair a natural brown-gray mottled appearance, which blends into the color of the mountain rocks.

Chipmunks And Ground Squirrels

Chipmunks are lively little rodents, active during the day! They have light and dark stripes on both the body and the face. The Golden-mantled Ground Squirrel illustrated below also has stripes, but not on the face. It was painted first, then textured with ink work.

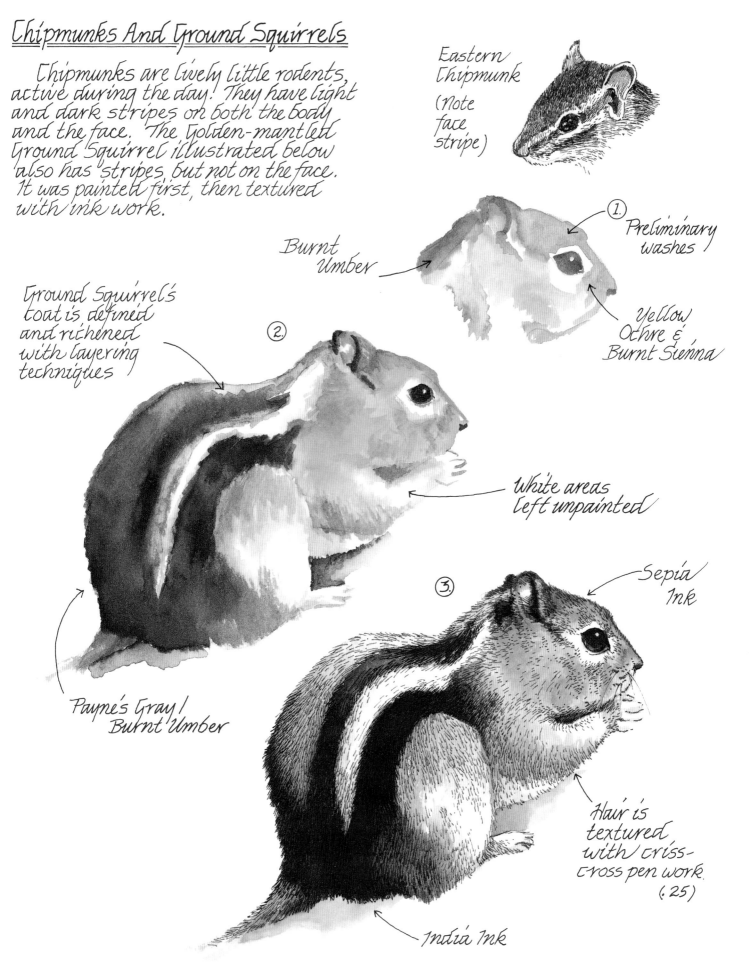

Eastern Chipmunk (Note face stripe)

Burnt Umber

① Preliminary washes

Yellow Ochre & Burnt Sienna

Ground Squirrel's coat is defined and richened with layering techniques

②

White areas left unpainted

Payne's Gray / Burnt Umber

③

Sepia Ink

Hair is textured with criss-cross pen work. (.25)

India Ink

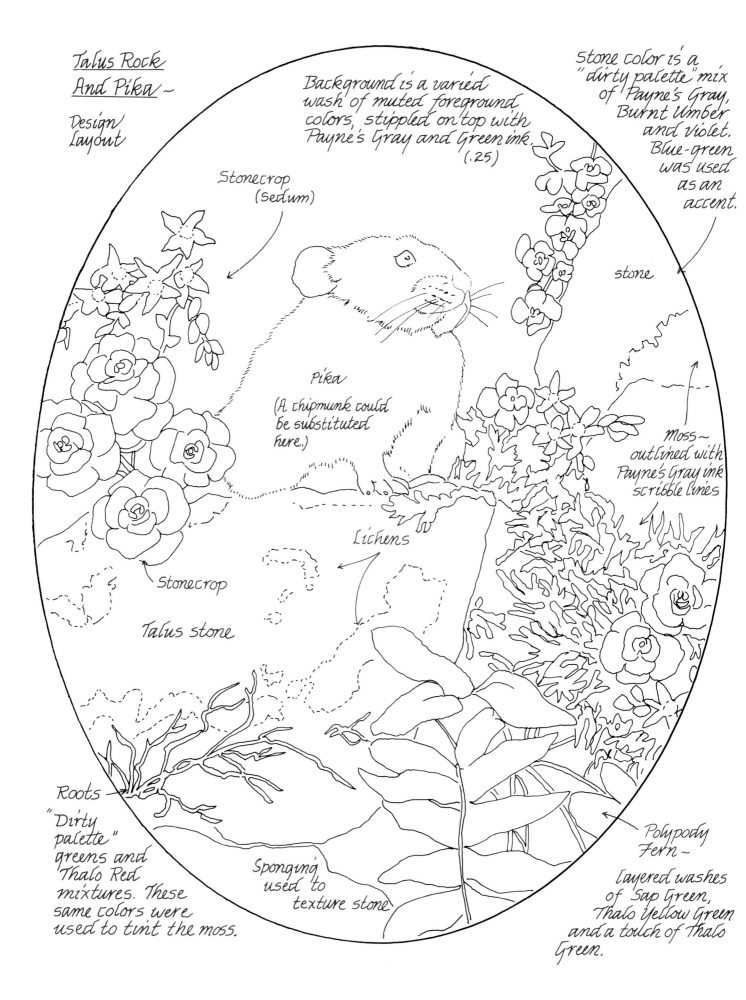

Talus Rock
And Pika –

Design
Layout

Background is a varied
wash of muted foreground
colors, stippled on top with
Payne's Gray and Green ink.
(.25)

Stone color is a
"dirty palette" mix
of Payne's Gray,
Burnt Umber
and Violet.
Blue-green
was used
as an
accent.

Stonecrop
(Sedum)

stone

Pika

(A chipmunk could
be substituted
here.)

Moss –
outlined with
Payne's Gray ink
scribble lines

Lichens

Stonecrop

Talus stone

Roots

"Dirty
palette"
greens and
Thalo Red
mixtures. These
same colors were
used to tint the moss.

Sponging
used to
texture stone

Polypody
Fern –

Layered washes
of Sap Green,
Thalo Yellow Green
and a touch of Thalo
Green.

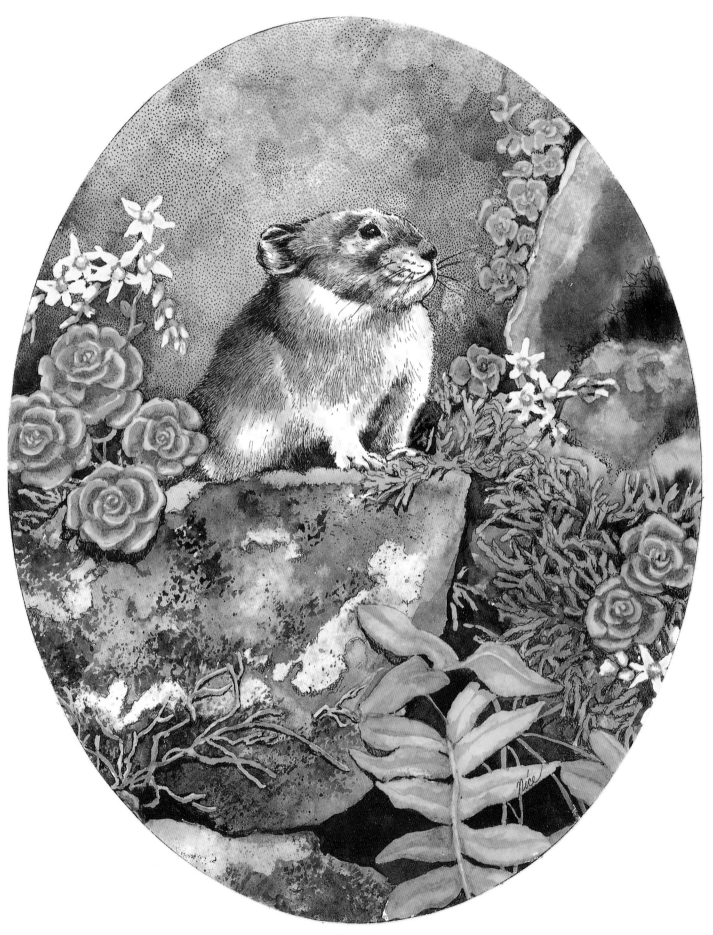

TALUS ROCK AND PIKA, 8″×10″ (20.3cm×25.4cm), watercolor
washes textured with spatter, alcohol streaks and India ink penwork

Cascading Water

Snow melt, tumbling over rocky mountain walls makes a wonderful contrast of dark, wet stone and white water. Here's one way to depict it—

Sap Green for moss

① Thin liquid frisket with a little water so it flows easily and block out water and high-light areas. Lay in a varied wash of earthy grays & browns.

② Create spontaneous rock shapes by pressing wrinkled plastic wrap into the wet base washes. Let dry.

③ Using the rock shapes as a guide, brush in shadows and additional glazes of color. Maintain good value contrasts in the rock wall.

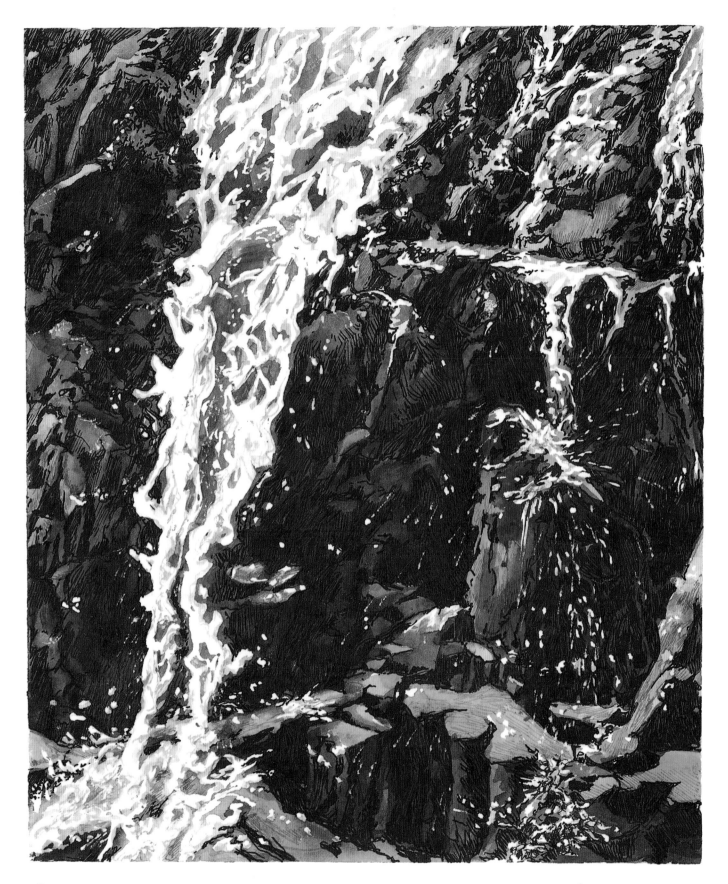

④ Further shape and texture the stone walls using black and brown inks and a Rapidograph pen. (.35) Scribbly contour lines work well.

⑤ Use a small detail brush and a pale Ultramarine Blue / Burnt Umber wash to shade the edges of the cascading water. Add drips and spatter with a razor blade.

121

Snow

Unless it is tinted with warm reflected color, snow is white --- unpainted paper white. Shadows give snowbanks their definition. These cast shadows are cool grays and muted blues, ranging from violet to aqua. The snow washes used in these examples are varied mixtures of Payne's Gray and Ultramarine Blue.

Snow flakes can be easily suggested by sprinkling table salt into a damp surface wash.

Unpainted areas depict sunlit snow surfaces.

Preliminary shadow areas, are brushed in wet-on-wet.

Snowbank shadows are deepened using layering and damp brush blending techniques.

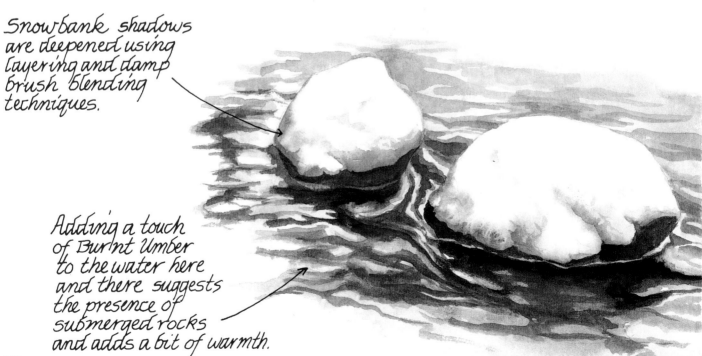

Adding a touch of Burnt Umber to the water here and there suggests the presence of submerged rocks and adds a bit of warmth.

Here is a miniature scene on which to hone your snow painting skills. ——

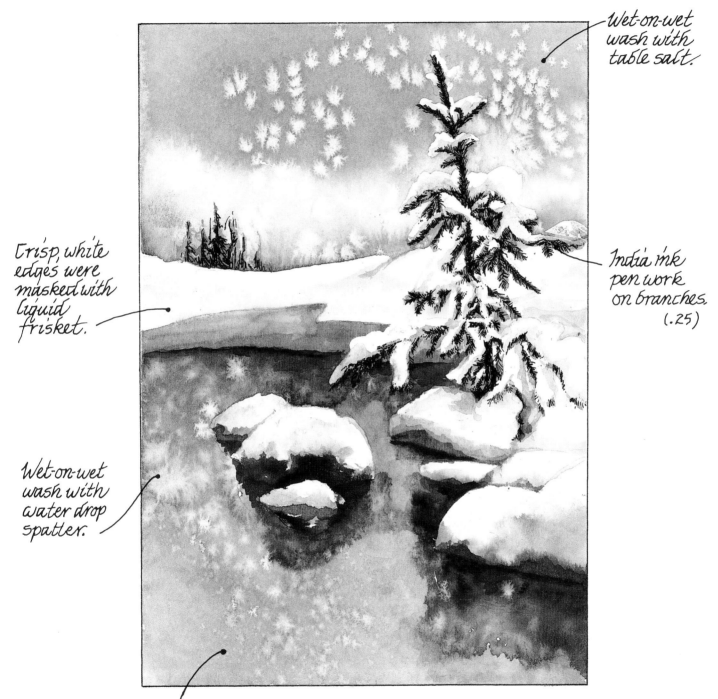

Wet-on-wet wash with table salt.

India ink pen work on branches. (.25)

Crisp, white edges were masked with liquid frisket.

Wet-on-wet wash with water drop spatter.

Water is still, in a near frozen state. There are no ripples.

Palette: Payne's Gray
Ultramarine Blue
Burnt Umber
Sap Green

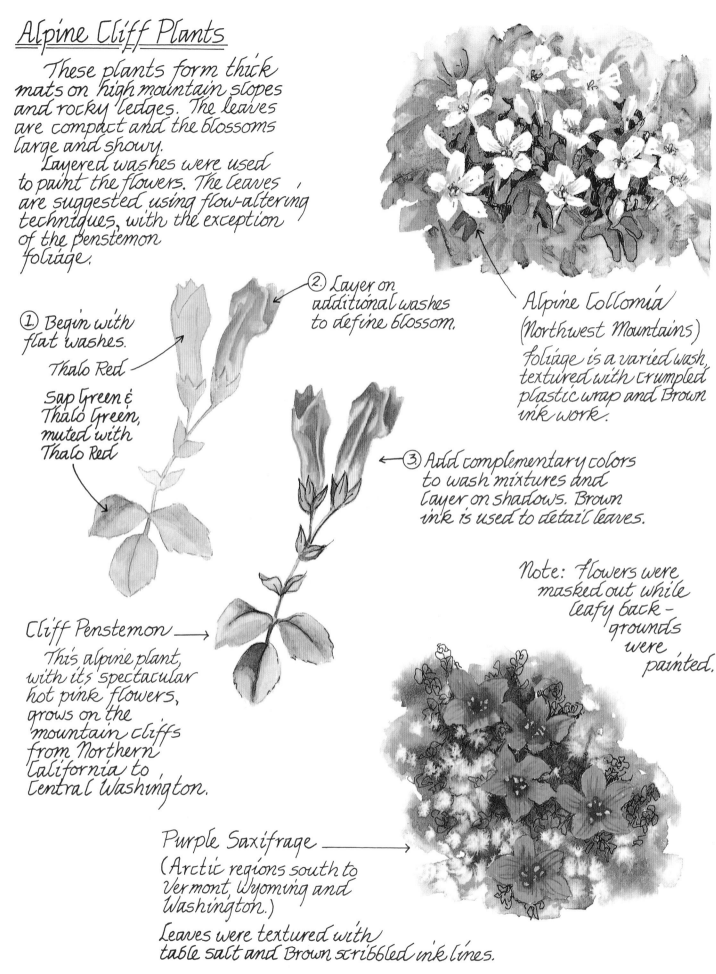

Alpine Cliff Plants

These plants form thick mats on high mountain slopes and rocky ledges. The leaves are compact and the blossoms large and showy.

Layered washes were used to paint the flowers. The leaves are suggested using flow-altering techniques, with the exception of the Penstemon foliage.

② Layer on additional washes to define blossom.

① Begin with flat washes.

Thalo Red

Sap Green & Thalo Green, muted with Thalo Red

③ Add complementary colors to wash mixtures and layer on shadows. Brown ink is used to detail leaves.

Alpine Collomia
(Northwest Mountains)

Foliage is a varied wash, textured with crumpled plastic wrap and Brown ink work.

Note: Flowers were masked out while leafy back-grounds were painted.

Cliff Penstemon ———→

This alpine plant, with its spectacular hot pink flowers, grows on the mountain cliffs from Northern California to Central Washington.

Purple Saxifrage ————
(Arctic regions south to Vermont, Wyoming and Washington.)

Leaves were textured with table salt and Brown scribbled ink lines.

124

Bald Eagle

The Bald Eagle is a fish-eater, dwelling near large bodies of water across North America. Preferred nesting sites are in the tops of tall trees. When trees are scarce, mountain bluffs and cliffs support the large stick nests.

Brown body feathers

Preliminary wash of Yellow Ochre, Thio Violet, Burnt Umber and a touch of Payne's Gray.

Add more Burnt Umber and Payne's Gray to the previous mix and darken the feathers, leaving the bottom edge light. Blend with a clean, damp brush.

Yellow Ochre plus Thio Violet

Yellow Ochre, Thio Violet and Burnt Umber

Eye: Yellow Ochre plus Gamboge. Add Burnt Umber for shadows.

Ultramarine Blue, Thio Violet and Payne's Gray

Burnt Umber, Thio Violet and Payne's Gray

① Preliminary washes. (Leave plenty of unpainted white areas).

② Deepen color and add shadows using a no. 4 round detail brush and layering techniques.

The eye area was further defined with Sepia pen work.

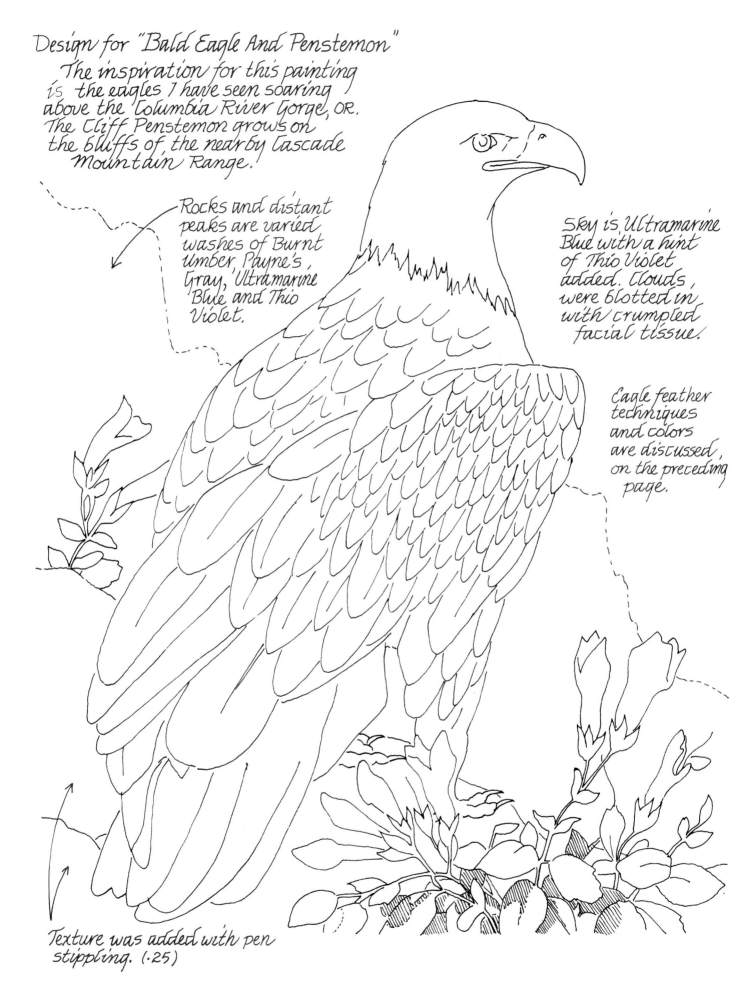

Design for "Bald Eagle And Penstemon"
The inspiration for this painting is the eagles I have seen soaring above the Columbia River Gorge, OR. The Cliff Penstemon grows on the bluffs of the nearby Cascade Mountain Range.

Rocks and distant peaks are varied washes of Burnt Umber, Payne's Gray, Ultramarine Blue and Thio Violet.

Sky is Ultramarine Blue with a hint of Thio Violet added. Clouds were blotted in with crumpled facial tissue.

Eagle feather techniques and colors are discussed on the preceding page.

Texture was added with pen stippling. (.25)

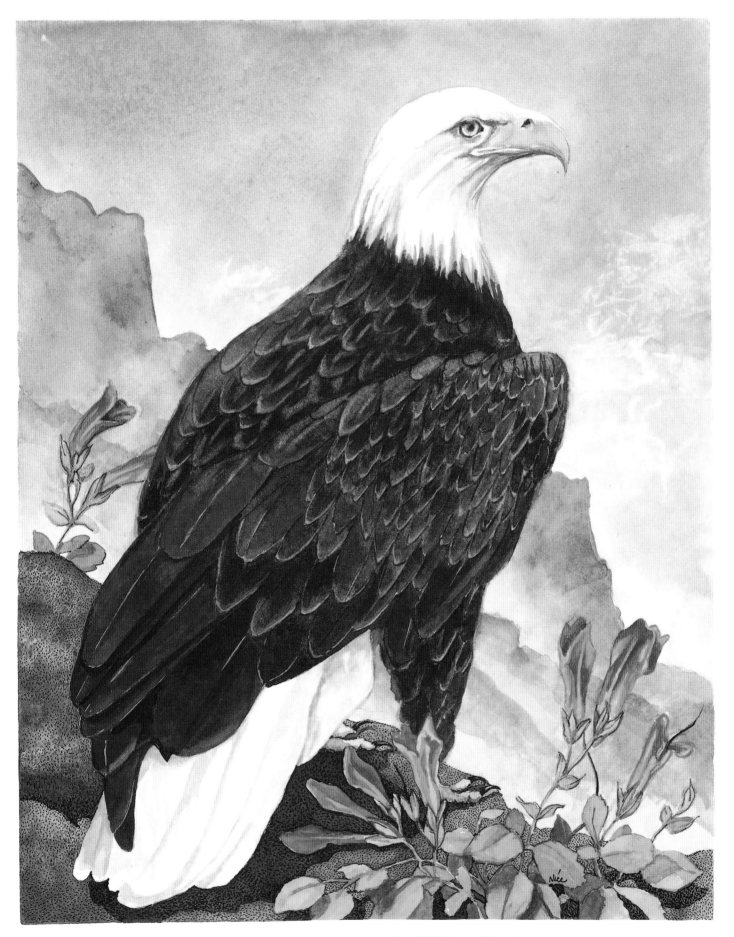

BALD EAGLE AND PENSTEMON, 8″×10″ (20.3cm×25.4cm),
layered watercolor washes and ink stippling

INDEX